A Modern
Photo
Guide

Trick
Photography

Minolta Corporation
Ramsey, New Jersey

Doubleday & Company
Garden City, New York

Minolta Corporation
Marketers to the Photographic Trade

Doubleday & Company, Inc.
Distributors to the Book Trade

Library of Congress Catalog Card Number: 81-71309
ISBN: 0-385-18154-x

Cover and Book Design: Richard Liu
Typesetting: Com Com (Haddon Craftsmen, Inc.)
Printing and Binding: W. A. Krueger Company
Paper: Warren Webflo
Separations: Spectragraphic, Inc.

Manufactured in the United States of America
10 9 8 7 6 5 4 3 2 1

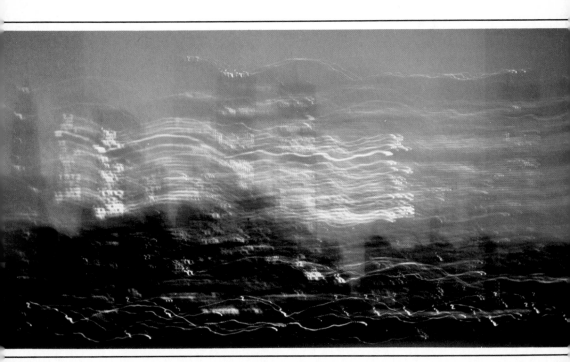

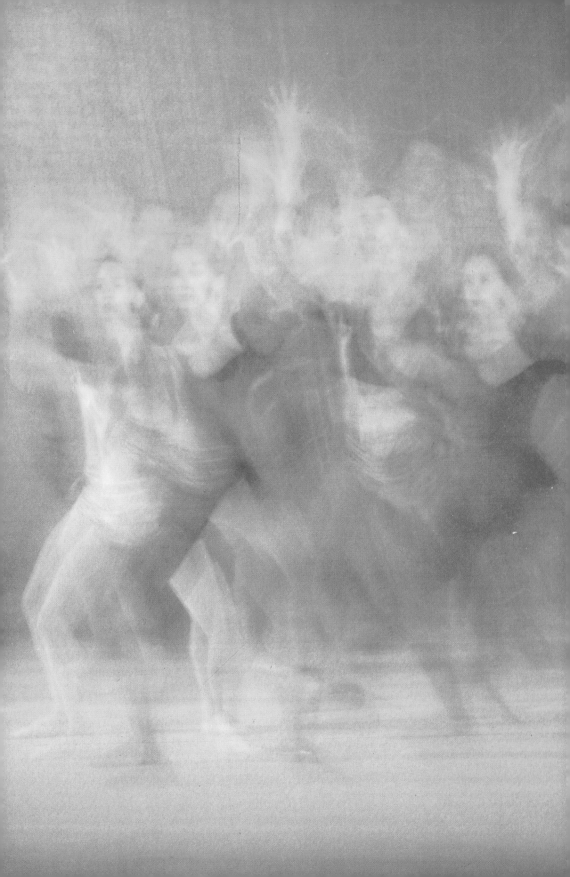

Contents

Technique Tips

Throughout the book this symbol indicates material that sup-
plements the text and which has been set off for your special
attention. You can apply the data and information in these
Technique Tips immediately to get better results in your pho-
tography.

Introduction

Magic! That is what photography is. It can make people disappear
... rabbits multiply themselves ... day turn into night ... green leaves
fade to white. What you see does not have to be what you get!

Trick photography is the magic of *special effects*. It is the creation
of images where your imagination runs wild and no one can say you
are doing the "wrong" thing. There is no such thing as wrong in this
area of photography that allows you to break rules and have fun mak-
ing unique images.

Whether you call it trick photography or special effects photogra-
phy, you do need to know the basics of conventional photography. You
should know how to focus and hold your camera steadily, as well as
understand the variables that control exposure. Then you will be com-
fortable in knowing how much you can deviate from an accepted proce-
dure for the photograph to look good and not like a mistake.

Most of the effects in this book do not need any specialized equip-
ment other than what you commonly use. Some tricks require accesso-
ries from photo or art stores. Many times it is possible to make your
own accessories from odds and ends around the house or from some-
thing you can buy in a hardware store.

At the beginning of each section is a list of accessories you will need
in order to try the effects. You do not have to run out and buy all of
them. The chapter on special-effects lens attachments, for example,
describes a dozen different devices, but you may want to own only one
or two of them. Read the chapter, look at the illustrations, and see
whether you can borrow the accessory from a friend in order to try it
before you invest in it. Other devices are as simple as a mirror or a few
yards of black cloth. If you like the effects you can get, these will not
bankrupt your photography budget.

*Special effect pictures often use more than one trick. A circular-image fisheye lens pro-
duced the shape distortions; see Chapter 2. The unusual tonality was produced by
solarization—briefly flashing the print with white light about half-way through develop-
ment. Photo: P. Bereswill.*

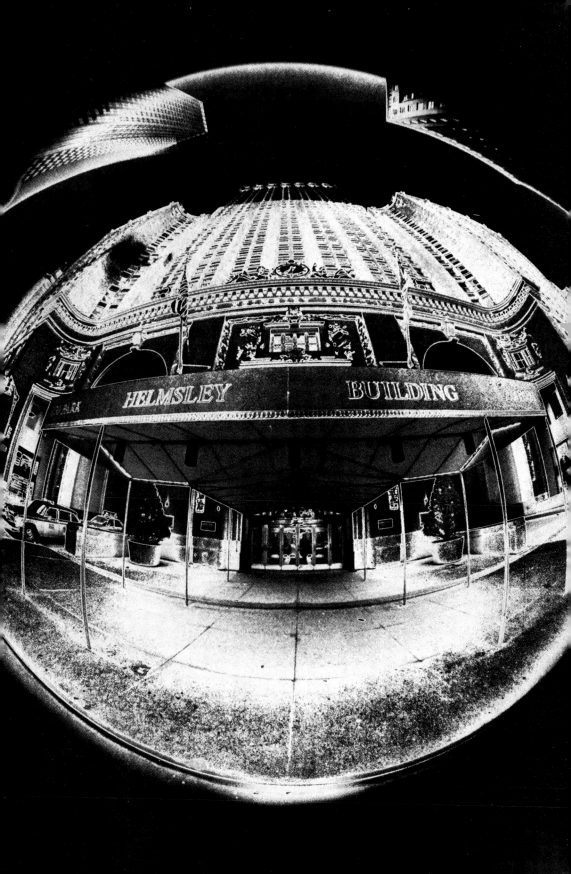

Photographing through a strongly colored filter is the simplest way to achieve an unusual color effect. For additional filter tricks, see Chapter 1. Photo: Courtesy Cokin.

One accessory, the tripod, is so essential it really should be considered as much a part of your equipment as the camera. Some effects require special lenses or an electronic flash, but the one thing you will need over and over is a good sturdy tripod.

There is a source list in the back of the book to help if your local stores do not have particular items. You may be able to order them directly from the manufacturer or have your store get them for you. There are also several mail-order suppliers listed, and these may be your best resource of all.

This book assumes that you are curious, imaginative, and like to try new ideas. Experiment. All of your photographs will not be tremendous successes, but you will have fun creating them. Many of the pictures will astound you with their beauty, their drama, their novelty or their humor. People frequently forget that humor has a place in photography, and a few of these techniques offer ways to achieve it.

Many photographs can be shot in a conventional way—no tricks involved—and then altered in the darkroom. Therefore it is important to discover some of the secrets of this magical place. If you have not ye

started to print your own pictures, this section ought to make you curious. Look through the chapter even if you do not have a darkroom. Then, when you get excited about the creative possibilities that are open to you, learn the basics from *Basic Black-and-White Developing and Printing* (also in this series). Some of the techniques do not even need an enlarger, and some give you ways of altering prints you already have.

You may continue to shoot photographs for both prints and slides in conventional ways. But when you have the urge to add excitement and drama—and just plain have fun—try a special effects technique. You will never get bored.

Colored light sources can transform a subject an ordinary night scene into a mysterious location. The same technique applied in the studio can produce effects that range from subtle and delicate to bizarre and dramatic. Light tricks are covered in Chapter 5. Photo: D. Gray.

1

Tricks with Filters

Filters for Black–and–White Film

MATERIALS AND EQUIPMENT: Color filters to fit over your lens in one or more of the following colors: red Nos. 25 or 29, yellow Nos. 8 or 15, green Nos. 56 or 58, blue No. 47, orange Nos. 16 or 21; polarizer; tripod.

How Filters Work. Filters do one thing: they filter out some of the light entering the lens. White light is actually a mixture of red, green, and blue light, and the objects illuminated by white light reflect their own colors from the natural spectrum. When you put a colored filter in front of the lens, the filter will hold back certain of these colors while allowing others to enter the lens and strike the film. If you know the rules, it's fairly easy to predict which colors a filter will pass and which it will hold back.

A filter itself appears to be a certain color because that is the color it transmits. So, if the filter is blue, you will know it is holding back red and green but pàssing blue. If the filter is red, it will filter out blue and green and transmit its own color, red. And if the filter is green, you know it will hold back red and blue while passing green. Yellow light is strange; it is actually composed of red and green. So a yellow filter in front of the lens will pass red and green while blocking blue. The basic rule for black–and–white film is: to lighten a color in the scene, use a filter of the same color; to darken it, use the opposite color or consult the chart.

Filters are made in different strengths; that is, they range in hue from pale to deep. In a particular color range, the higher the identifying number, the deeper the hue and more pronounced the effect. The filter colors in the opening list are much deeper than colors you would use for general photography. They are some of the deepest hues made, and they will, indeed, give you something special.

Silhouetted forms appear natural rather than abstract when seen against rich tones. A medium yellow filter will deepen sky tone and its reflection on water, and will make clouds stand out more clearly. Photo: P. Bereswill.

Because a filter holds back some of the light, you will have to increase the amount of exposure you give the film. With through–the–lens metering, you can rely on the meter reading you get when the filter is in place except with the very deep filters. With these, it is best to shoot additional bracketed exposures.

Creative Filtration. Now that you have all that theory behind you, what creative things can you make these filters do? How about changing a light blue sky into a very dark, almost black one? A yellow filter will hold back the blue of the sky, causing it to darken. But yellow filters are not terribly dense, so the effect will be only moderate. Orange will give a more pronounced effect, but red can give spectacular dark skies. Try red when there are fluffy white clouds or when you can place white buildings in the foreground. To exaggerate the effect even more, place a polarizing filter over the lens, and then a red filter over that. If you want to create the look of nighttime, even in broad daylight, underexpose the film a bit.

If you remember the rule that the filter will lighten things the same color as it is, you can exaggerate the tonal difference between objects, maybe realistically, maybe not. If your subject is a yellow daffodil against a blue sky, you could alter the realistic rendition of the scene by photographing through a blue filter. The tonal effect would be completely opposite — dark flower and white sky.

A deep blue filter will lighten any blues in the scene until they are almost white, and it will darken other colors. Interestingly, it can accentuate atmospheric haze, giving a unique appearance.

A dark green filter can emphasize the texture and the tan of a person's skin, which can be especially dramatic in male portraiture. But if the subject has freckles or skin blemishes, beware; these will turn to black splotches on the picture. If you want to do instant cosmetic surgery on a person with a poor complexion, use a light orange filter. Since this also lightens lips, have your female models use a slightly darker lipstick.

Another bit of magic a filter can do is remove stains and discoloration when copying a document. Simply use a filter that is the same color as the stain, and the stain will disappear—photographically, at least.

FILTERS FOR BLACK–AND–WHITE PHOTOGRAPHY		
Color of Subject	Filter Color to Lighten Subject	Filter Color to Darken Subject
Red	Red, yellow, orange	Blue, green
Orange	Orange, yellow, red	Blue, green, purple
Yellow	Yellow, orange, red, green	Blue
Green	Green, yellow	Red, blue, purple, orange
Blue	Blue	Yellow, red, orange, green
Purple	Purple, blue, red	Green, orange

Black-and-white filter effects are most noticeable under daylight. (Left) Natural rendition. Compare gray tone of hair, skin, lips, and red blouse with filtered shots. (Below left) Red filter lightens its own color. (Below right) Green filter darkens those colors. Photos: J. Scheiber.

Filters for Color Film

MATERIALS AND EQUIPMENT: As many of the following as you can buy or borrow: richly colored effect filters intended for color photography and black-and-white contrast-control filters, sepia filter, variable color polarizers, holographic diffraction filters, graduated color filters, color filters with clear centers; tripod.

Most of the time photographers use filters with color film to render colors realistically. But in special effects work, you are not bound by a conventional approach. You might want to use color to exaggerate an effect, suggest a mood, or create a totally unreal environment.

As you see from the list above, filter manufacturers are committed to making photographic life colorful. Some of the filters are available only in glass, others only in the newer "organic glass" (plastic), and some types are offered in both. You also can buy gelatin filter squares, which fit in front of the lens in a special filter holder. These are delicate, but are considerably less expensive than the others.

The nice thing about using an SLR camera is that you will be able to see the effect of the filter and judge whether you like it before you snap the shutter. You can also let your camera's metering system determine the exposure for you, although it is a good idea to bracket the exposures. Try intensifying a sunset or making a sunset out of a daytime scene with a deep orange, red, or purple filter. Warmer colors seem to be most successful in landscape shots, although blue can dramatize a snow scene. Try any of the colors with a silhouetted foreground. If the subject has pale tones of one color, you may want to emphasize it by adding a filter of a similar color. If you try a deep blue filter and slightly underexpose the scene, it will look as if it were taken by moonlight—especially if there are no givaway long shadows. A sepia filter will add a quaint, antique look to the picture.

One kind of diffraction filter will produce pulsing red, green, and blue streaks from a direct light source in the picture. Photo: D. Cox.

Polarizing color filters change color depth as they are rotated. Bicolor filters of this type shift between two colors, with an equal blending at the halfway point. Because these filters absorb a lot of light, you'll need a tripod except under bright illumination. Photo: D. Rosener.

Polarizing Color Filters. Even more exciting are the polarizing color filters. These work in an amazing way. As you rotate the filter, the color actually changes. With one type of color polarizer, the hue goes from neutral, the way the scene actually is, to an ever deepening saturation of that color. With the other type, rotating the filter changes the color from one hue to another—red to blue, yellow to green, orange to green, and so forth, depending on the filter you select. The midpoint between the two colors will be a blending of them. With these bicolor filters, there is an another incredible effect. By changing the position of the polarizing part of the filter, you can produce reflections that are in one of the filter's colors while the rest of the scene is the other color. There are two disadvantages to these filters. One is that they are so astounding to work with that you may abandon using everything else, and two, they do block a lot of light from the film plane. Therefore, you need to shoot in bright light, or use a tripod for long exposures.

Graduated Color Filters. Graduated color filters are those with a color that gradually feathers off into a clear area or sometimes into another color. If you line the filter up appropriately, you can do things like darken a sky, add a new color to the foreground, or intensify the color in part of the scene. With glass filters, you have to position the camera so the area of the scene corresponds to the color split in the filter. With a plastic filter, you can maneuver the filter in the holder to make the spot fall exactly where you want it. It is also possible to put one color on the top and another on the bottom.

Filters that have a clear spot in the center surrounded by a colored area offer an attractive way to do a portrait or even a scenic, where you want to emphasize one element.

With both the graduated and the center–clear filters, the larger the lens aperture and the longer the lens, the less noticeable will be the demarcation between the clear and colored areas. This fact must be taken into consideration when deciding how dramatic you want the filter effect to be. It is best to meter the scene without these filters in place. If you rely on your camera's metering system, the clear part will be overexposed.

Diffraction Grating Filters. The most dazzling of all color effects comes from filters made of holographic diffraction grating materials. Imagine bright points of light surrounded by streaks, crowns, or stars in a rainbow of colors. These filters are made in several different patterns. You can also buy small sheets of the material which you can put into a gelatin-filter holder. Most of them give their best effects with lenses of focal lengths under 135mm. Underexposing one–half or one f–stop will intensify the colors if you are using them against a light background. However, the color effect will be most intense against dark backgrounds.

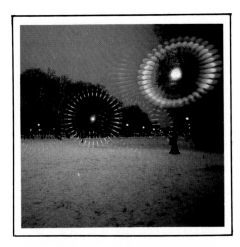

You can choose among many different patterns when you want to add diffraction-filter effects to your pictures. Photo: Courtesy Cokin.

The Magic of Polarization

MATERIALS AND EQUIPMENT: Polarizing filter, sheet of polarizing material, birefringent materials, red and green filters.

The effects of a polarizing filter (frequently called a polarizer) are sometimes so incredible that it can be regarded as a special effects filter, as well as being the most useful all-around filter.

When light strikes any nonmetallic surface, some of that light is reflected as polarized light, which we see as a whitish glare. A polarizing filter placed in the path of this light will pass the light or block it, depending on the degree of rotation of the filter. When light from the sky strikes particles of moisture and dust in the atmosphere, of a scenic view for instance, some of that light is reflected as polarized light. The polarizing filter can remove this light, allowing you to view the whole scene more clearly. Leaves, flowers, grass, people—everything except metal—also reflect polarized light. We may see it as glaring highlights, or we may not even be aware of how it is robbing the scene of its color. A polarizing filter over the camera lens will cause the colors to become deeper and more saturated. The filter is equally at home with color or black–and–white films.

Suppose you want to photograph through a window, but the detail of the scene is just about obliterated by the reflections on the glass. Since these reflections are polarized light, a polarizing filter on the

Subjects that are photographed under very bright light often display washed-out colors.

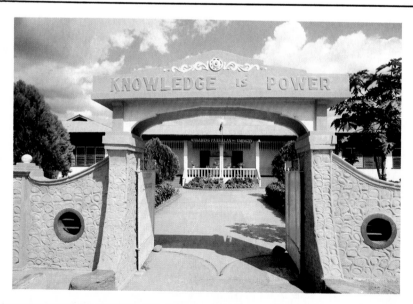

18

camera will cause the reflections to disappear. Try the polarizer when you want to photograph a painting covered with glass, a shiny-surfaced piece of paper, or your goldfish in their aquarium. A word of warning about photographing a large body of water: you may not want to eliminate all the reflections. Without some reflections, water is strange and unnatural looking. Similarly, you will need a slight amount of reflection on glass so it will not look like air.

The polarizing filter rotates in its mount, and by rotating it you have complete control over the amount of reflection you reduce. Another effect you should be aware of is that at the minimum polarization position, the polarizer slightly *increases* the amount of reflection. With SLR cameras, you can see exactly the effect you will get on film as you rotate the filter.

You also must consider the angle at which the camera faces the surface. If it is squarely in front of it, you will not get any reduction in reflections. For the maximum effect, you must be at an angle of about 30–40 degrees. To darken the sky to its maximum, take your pictures with the camera at a 90–degree angle to the sun. Beware of wide–angle lenses—they may take in so much area that part of the sky will be polarized and part may not be. It is easiest to rely on what you see through the camera viewfinder, and if need be, change your position in relation to the reflecting surface.

Use your camera's meter to determine the exposure. A few cameras may not meter a polarizer accurately, so consult the instructions for specific information.

A polarizing filter can bring about dramatic changes in color saturation without changing the actual quality of the colors in the scene. Photos: B. Sastre.

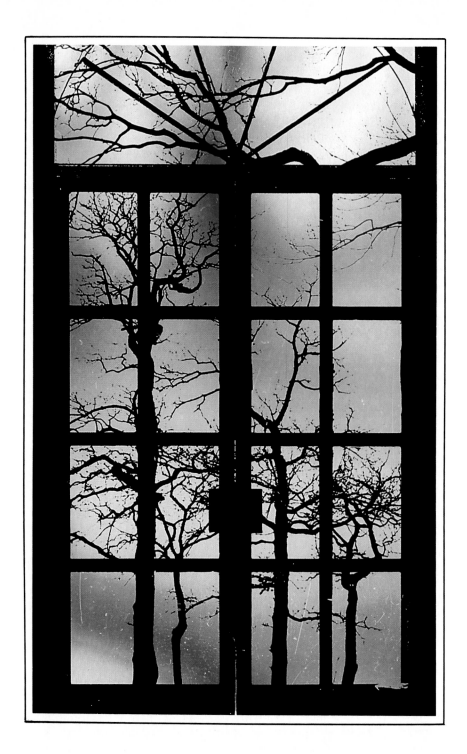

Polarizers plus some birefringent material can turn an ordinary silhouette into something quite unusual. Place one or more layers of slightly crumpled cellophane or plastic material between two polarizers and rotate the filters for a variety of abstract color patterns. Photo: E. Stecker.

Instead of reducing reflections, a polarizer can be used to deepen color and emphasize glare, adding brilliance to surfaces in a picture. Photo: D. Cox.

Polarizing Filter Effects. A polarizing filter plus a deep red or green filter will intensify the image on black–and–white film. With red, you will get dark skies and a nighttime effect. With green, foliage will turn white, much as it does with infrared film. When combining a polarizer with another filter, put the polarizing filter closest to the lens.

Polarization can help you make some colorful abstract pictures. You will need some sheets of polarizing material and some birefringent material. Birefringent substances are those which are uncolored in ordinary light, but will display color when placed between pieces of polarizing material. Cellophane, Mylar, and many plastics have this property. Lay the object to be photographed on top of a sheet of polarizing material, with a source of light behind it. You can either put another sheet of polarizing material on top of the object or put a polarizing filter on the camera. If you are using cellophane, crumple it, fold it, or pile small pieces one on top of the other at different angles. The more layers, the more colors you will get—and those colors will change as you rotate the top polarizer. Try stretching the cellophane or heating it. Or take a clear piece of plastic and criss–cross it with many layers of clear cellophane tape, not the frosted variety. Try all the plastic boxes and containers you have around the house. You will be surprised by their beauty as you view them through different positions of the polarizer.

Do–It–Yourself Filters

MATERIALS AND EQUIPMENT: Pieces of .005 clear acetate, pieces of colored acetate, transparent paints, colored cellophane, gelatin filter squares, gelatin filter holder, transparent tape, circle template.

Filters you make yourself generally are not the unblemished optical quality of commercial filters, but the distortion they impart may add a special quality to the effect. At any rate, they are fun to make and allow you to create images that are not possible any other way.

Coloring Clear Acetate. Here's an unusual start: hand–color large, irregular shapes on a piece of clear acetate. When this is placed in front of the lens, it will add diffused areas of color to the image. You must use colorants that are especially formulated to adhere to acetate. You can also use felt markers. Permanent-type markers or those sold for use on overhead projection transparencies are satisfactory. With the dyes or inks, dribble one or two colors over a 7.5cm-square (3″ × 3″) piece of acetate. It's best to leave the center clear rather than putting color over the entire filter. You might want to cut a hole in the center of the filter so the image will be sharp. You can vary the density, especially when using just one color. You might even try spatter-painting by dipping an old toothbrush in the color and flicking it with your thumb (wear rubber gloves!) or rubbing it over a piece of screen so it leaves a fairly uniform pattern on the acetate. Marking pens give rather streaky colors, but they will make acceptable filters. While you are at it, make several filters so you can see which effects you like best.

To use the filter, hold it or tape it in front of your lens, though you will find it is easier to manage if you put it into a gelatin filter holder. This filter holder slips over the camera lens and holds 7.5cm squares of gelatin filter or acetate. If you have one of the commercially-made plastic-filter systems, you already have a holder that will accept your handmade filters. Because they are quite close to the lens, the edges of the colors will blur, adding an ethereal or dramatic note to your picture, depending on the intensity of the colors.

You can buy sheets of colored acetate in art supply stores or directly from the manufacturers. The color range is nothing short of spectacular—everything from palest amber to deepest purple. These are not optical quality, but you may want to use them anyway. Their price makes them worthwhile to experiment with, and they will work fine for many pictures. If you want true optical quality, buy gelatin filters from Kodak or one of the other filter manufacturers. These come in 7.5cm-square size to fit the filter holder. They scratch easily, so handle them with care, just as you would a lens.

Filter holders designed to be attached to the front of the camera lens are produced by a variety of manufacturers. The filter material may be inserted either before or after attaching the holder to the camera.

Colored Cellophane and Acetate. Another way to add color is to place a piece of colored cellophane—not plastic—over the lens. It distorts a great deal, and you may want to exaggerate this characteristic by crumpling the cellophane and then smoothing it out. Cut a hole in the center and you will have a sharp central image surrounded by pleasingly blurry areas.

Both the colored acetate and gelatin filters give you the opportunity to construct multi–colored filters, with the split wherever you want it. Cut the acetate into 7.5cm squares, then into the desired halves or quarters. It is a good idea to protect this material between layers of tissue paper or lens tissue while you cut. Be sure the pieces that are to butt against each other are cut perfectly straight.

Multi–Color Filters. You can make filters that have two colors, with the split running from top to bottom or from side to side. You can even assemble three– and four–color filters. Or you can make just a sectional filter by placing a small piece of colored material in only a portion of the holder. This is a good way to tint or tone down a too bright sky while adding a dramatic effect.

Making your own filters also gives you a range of colors for a center–sharp effect. Cut a circle out of the center of the desired color. Trace the circle with a template available in any art or school supply store. When these filters are placed close to the lens, with the lens open to a wide aperture, the various colors will blend softly into each other.

Metering for any of the special effects filters can be done through the lens of the camera, except for filters with clear areas. With these, take your meter reading without the filter, and lock in the setting. It will cause the colored part to be slightly underexposed, which will be pleasing.

2

Tricks with Lenses and Front-Attachments

Extreme Wide–Angle and Fisheye Lenses

MATERIALS AND EQUIPMENT: Wide–angle lens of 20mm focal length or less, fisheye lens, auxiliary fisheye lens, super–wide–angle lens attachment, wide–angle peephole lens, screw–on lens cap.

The design of these lenses, which encompass a super–wide view of the world, introduces an element of unusual spacial relationships and distortion. Your normal lens probably has a focal length of about 50mm. Everything it photographs appears in the correct proportion to everything else, straight lines are straight, and distances between objects in the foreground and the background look "right." But a wide–angle lens can change all that. As focal lengths become shorter and shorter, strange things begin to happen. Objects in the foreground look much larger than they are in life, distances seem much greater, and straight lines may be curved. All this plus the fact that the lens is able to photograph a much broader view of the scene.

Some of this distortion starts with a 28mm lens. Do not take close–up pictures of friends with this lens unless they possess a sense of humor. At close range, the person's nose will appear enormous and the ears will seem far away and small. If you do this with a 20mm lens, that friend may not let you take his picture again! But this is where you can start making the characteristics of the lens work for you. Hands, feet, or tree limbs placed near the lens will be exaggerated in size and, therefore, in importance. If you compose carefully, these elements can add power to your picture. The 20mm lens is one you should work with for awhile to get the feel of what it can do for your photographs. For example, in a relatively uninteresting scene, try placing a small object

An extreme wide-angle lens can exaggerate perspective greatly. Use the effect with an appropriate subject, such as these skaters on stilts. Just a tiny shift in camera position will make rather strong changes in the image, so check the effect carefully through the viewfinder. Photo: M. Craig.

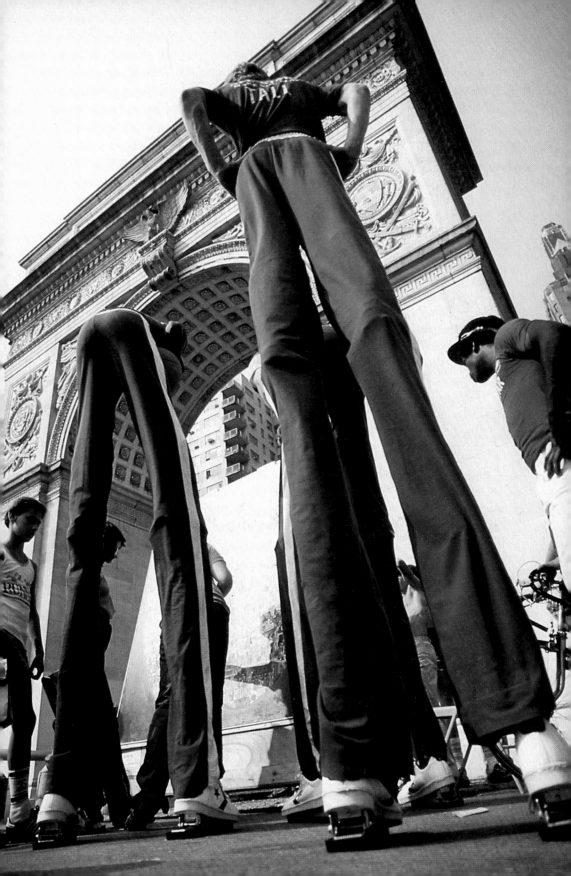

in the foreground; then move the camera close to it. Focused at short range, a wide–angle lens will exaggerate the size of the object, and its great depth of field will allow you to keep everything in the background in focus. If you use the lens to photograph the inside of your living room, the increased impression of spaciousness will convince everyone that you live in a palace. After all, cameras do not lie—or do they?

Fisheye Lenses and Accessories. The walls of the room may look slightly bowed if they are at the edges of your picture, and that curving appearance really becomes obvious with a fisheye lens. There are fisheyes that maintain the rectangular shape of the picture but bend lines near the edges. But to most people, a fisheye means a lens that "sees" the scene as a circle. These amazing lenses can photograph a 180–degree angle of view. Compared to the 45–degree angle of a normal lens, the fisheye is very special indeed. Unfortunately, so is the price. As much as you think you would like to own one of these, their price tags make them prohibitive unless you need to use one a great deal. Fortunately, there are attractive alternatives.

You can buy a reasonably-priced fisheye attachment that screws over your own normal lens and effectively converts it to a fisheye. It will not be quite as sharp as the true fisheye, especially at the periphery, but it will give satisfying pictures.

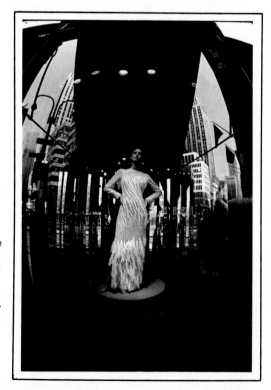

The curved distortion a fish-eye lens produces is least pronounced in the center of its field; that's the place to put your main subject. A full-frame fisheye, such as the one used here, produces less curvature than a circular-image design. With such an extreme angle of view, watch carefully to avoid including unwanted details at the edges of the picture. Photo: J. Scheiber.

Extremely short focal lengths take in a very wide angle of view, much like that of a fish's eye. Hence the name fisheye lens.

Technique Tip: Using a Fisheye Attachment

To use a fisheye attachment, your camera's lens must be wide open and you will set the *f*/stop on the attachment itself, taking the meter reading with a hand meter or through the lens *without* the attachment. This means you must be able to override your camera's automatic metering system. For the sharpest pictures, use an opening that is closed down two or three stops from the maximum.

There is such an incredible depth of field with this attachment that you do not have to bother focusing it, even when you are a few inches from the nearest subject. The hard thing about using it is trying to keep your fingers and feet out of the picture!

Another accessory you may like even better is a super–wide–angle attachment. When screwed onto a 28mm lens, it produces the round, fisheye effect of 150 degrees, just a little less than the fisheye attachment itself. The advantage is that you can take a meter reading through it, and when used at small apertures, the image is sharper than with the fisheye attachment.

Some things make ideal subjects for this type of image. Things that are curved or circular, such as spiral staircases and arched branches of trees, are "naturals." But you also might like to transform straight lines into curved ones—like children on a jungle gym or buildings. Look

Close-up equipment will let you show tiny subjects larger than life. A long focal-length lens with macro-focusing, or mounted on a bellows or extension tube, will give you a big image like this without being so close that you scare the subject away. Photo: J. Meadows.

Close–Up Lenses and Attachments

MATERIALS AND EQUIPMENT: Macro lens, close–focusing zoom lens, close–up lens attachments, reversing ring, split–field lens, extension tubes, tripod, cable release.

You do not need all of these things. They are listed because there is more than one way to bring your camera close enough to fill the frame with something as small as a dandelion in seed or the whiskers of your cat. Extreme close–ups of small objects, especially when enlarged on a screen, can be breathtaking.

What you need will depend on how close you want to get—and how much you want to spend. The specially designed macro lens delivers incredibly sharp pictures of objects less than 7.5cm (3 in.) long; with extension tubes, it can photograph something about 0.625cm (¼ in.) long—and smaller. With a 50mm lens alone, you cannot come closer than about 45 cm (18 in.) from the subject, while the macro lens lets you move to within inches—and the closer you come, the larger the object will appear. If you find that you enjoy close-up photography, a macro lens is an excellent investment, because it can be used in place of a normal lens for more conventional photography. Many zoom lenses have built-in close-up capability. By pressing a button or a lever you can photograph quite close to the subject.

Supplementary Close–Up Lenses. A macro lens is not the only way to do close–up work. You can buy inexpensive supplementary close–up lenses that screw onto your regular lens. These come in varying strengths, from +1 to +10; there is even a +20 and another that can be varied from +1 to +10. These are frequently called "plus lenses". The higher the number, the closer you can come to the subject. For even greater enlargement, you can stack two or three of the lenses together. If you do this, be sure to place the strongest one (highest number) next to the camera lens. The size of the image you get also depends on the focal length of the camera lens, and longer lenses will produce larger images. The most useful close-up lenses are +1, +2, and +3, and you can buy these together in a set. Close–up lenses will not deliver as sharp an image as a macro lens, but the quality is improved if you use an aperture of $f/11$ or $f/16$.

Split–Field Lens. An unusual type of close-up lens is a split–field lens, which actually covers just one half of your camera lens. A split–field lens enables you to position a subject very close to the camera and keep both it and the background in focus. It takes a little care to make it work perfectly. Focus the camera lens on the background, preferably at an infinity setting. Put the split–field lens on the camera and move the camera toward and away from the subject until the foreground object is in focus. Recheck your background focus and take the picture.

With a +1 lens, the object must be about 1 meter (40 inches) away; with a +2, about 0.5 meter (20 inches); and with a +3, about 0.3 meter (13 inches). In order to minimize the division between the two zones of sharpness, plan on positioning your subject in a place where there is no detail—perhaps a very light or very dark area.

Reversing Ring. Another inexpensive way to work close–up while retaining the sharpness of your camera's lens is with a reversing ring. This unusual gadget fits into your camera's lens mount as your lens normally does. But then, you turn your lens backwards, screwing the front of the lens into the adapter ring. The rear of the lens is now facing the subject. Since it is unprotected, be careful not to scratch it. The

A split-field lens allows you to focus sharply on two separate areas of a scene. Here, the flower in the left foreground and the roof of the building and the trees in the background are in sharp focus; the central area, however, is quite out of focus. Photo: J. Peppler.

amount of magnification depends on the focal length of the lens, but, surprisingly, the *shorter* the focal length, the *greater* the magnification will be. You can reverse a zoom lens, too, giving you variable amounts of magnification with one lens. In this position, you cannot focus the lens by rotating it; instead, you must move it nearer or farther from the subject. For any reversed lens, the through-the-lens metering system of your camera will most likely have to be operated in the "stop down" mode, so consult your instruction manual.

 Technique Tip: Getting the Best Results with Close-Up Equipment

No matter what method you choose to bring your camera close to your subject, here are a few suggestions that will help ensure good results.

1. It is important that you use a tripod. When you magnify the subject, you will magnify every bit of camera shake at the same time. Put your camera on a sturdy tripod and you will not have to be concerned with camera shake.

2. Use a cable release, because it will prevent you from jarring the camera when you press the shutter.

3. When photographing outdoors, observe how the slightest breeze makes plants sway. A barricade made of a couple of pieces of cardboard or a sheet of plastic can help. You may want to use a piece of colored cardboard to provide a complementary background.

4. You must focus carefully, but, most importantly, you must decide what to focus on. The area that will be in focus is very small in close-up photography. Sometimes this can be an advantage—you can focus on a flower and the leaves and background will surround it with a pleasant blur. You can increase the area that is in focus by using a smaller lens aperture. With smaller apertures, you'll have to lengthen your exposure time—another important reason for putting your camera on a tripod.

5. Indoors, you will probably need to set up lights. If so, you will find it easier to maneuver your lights if you have some distance between the camera and the subject. In this case, using a close-up attachment on a telephoto lens will allow you the extra space to work comfortably.

Multi–Image Prism Attachments

MATERIALS AND EQUIPMENT: Any of the special effects multi–image prisms, colored acetate.

There is a type of lens attachment that can multiply a single subject to make three, four, five, or six images of it appear in your picture. These are the multi-image prisms. There are several different varieties, each of which arranges the clones of your subject into a distinctive pattern. All of the prisms are made with rotating mounts, allowing you to place the images exactly where you want them.

One type of prism produces three images, all in a straight line. When you rotate the mount, all three images will rotate. Another type

Each facet of the multiple-image prism used for this picture was a different color. The result accentuates the repeat effect in striking way. Photo: J. Scheiber.

Use a kaleidoscope-prism attachment for a complex repeat pattern of mirror images. Photo: T. Tracy.

will hold the center primary image steady, while the other secondary images move around it. There is a five-section prism that works the same way, that is, the center remains static while the outside images can be rotated. A kaleidoscope–type prism has six pie–shaped sections, and all of them rotate as you turn the attachment. This is not like a true kaleidoscope where alternate images are mirrored images. Instead, all of the images are oriented in the same direction.

Another device is really two prisms, each with two sections. Instead of having one rotatable mount, it has two, leaving the number of images up to you. Line up the splits of both prisms so they coincide in the center of the picture, and you can make twins out of your subject.

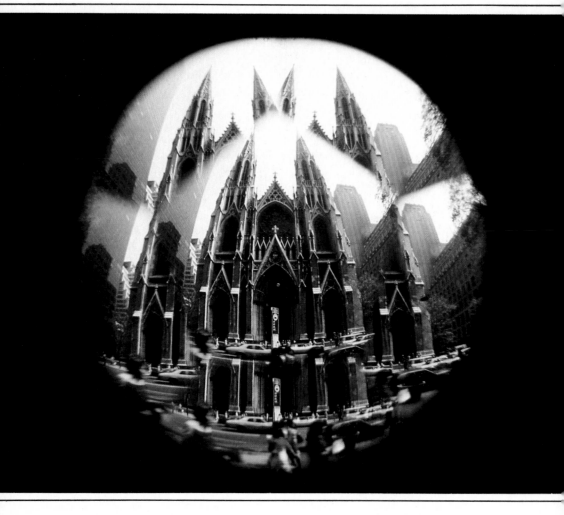

A multi-image prism attachment was combined with a circular-image fisheye lens for this unusual effect. Photo: M. Craig.

Align the split over an elongated subject, and you can make it seem to double its length. Rotate the splits and you can produce four images of equal or unequal area, depending on the angle of the prisms.

There is another prism in which half of the glass is clear, producing an undistorted image, but the other half is sectioned so it creates five images parallel to the main one. Depending on the size and positioning of the object, you can make one image turn into six, you can show a main image with fractional sections trailing out behind it, or you can make one elongated image. Its most clever use is to simulate the effect of exposing the subject with multiple bursts of a light.

Somewhat similar is an attachment that gives a clear undistorted

image in half of the scene, but blurs and extends it on the other side. This makes the subject look like it is in motion.

These are some of the imagination–stirring attachments that are available today. They are so popular with photographers that new ones emerge in the photo stores and magazine ads every year. Nevertheless, the principles in using all of them are similar.

Technique Tip:
Choosing Subjects for Prism Photographs

The choice of subject for trick photography with a prism is the most important thing to consider. Though everything looks fascinating through these prisms, remember that all subjects are not suitable for these effects.

Isolated subjects against a plain background generally are best, especially when the background is much darker than the subject. The sky is often a fine background and you can darken it with a polarizer. Busy scenes with many objects and people give a confused look, but photograph them if this is the effect you want to emphasize.

Thanks to reflex viewing you can see what the final image will look like. The depth of field preview button, which lets you view the image at whatever aperture you will be taking the picture, is especially important with prism attachments. With the aperture wide open, the secondary images become soft and blended, creating an ethereal, dreamlike quality. When the aperture is closed down, the images are separated and more distinct. With the five–parallel prism, the smaller the f/stop, the fewer the number of images.

These attachments are best with lenses of normal to moderate telephoto focal lengths. Wide–angle lenses cluster the images around the center of the picture, and telephoto lenses spread them out, sometimes cutting off part of the image. A zoom lens makes it convenient to vary the effect; and one in the 35–80mm range is excellent for this purpose.

The design of the kaleidoscopic attachment makes it somewhat difficult to focus the lens when it is in place. It is best to focus without the attachment, or estimate the distance and set this on the distance scale of the lens.

You have not begun to explore the potentials of these attachments until you combine two of them—either the same type or different ones. Rotate them until you see a pattern you like. Another embellishment is to tape tiny pieces of colored acetate over the the prism so the colors coincide with the various facets. Some prisms are already colored this way, but doing it yourself extends their versatility.

Diffusers and Star Attachments

MATERIALS AND EQUIPMENT: Diffusion attachment, fog attachment, star attachment, cellophane, woman's stocking, colored plastic, colored glass, skylight filter, colorless nail polish, petroleum jelly, piece of window screen.

All of your photographic life you have probably been striving to achieve the sharpest images possible, but with special effects photography, you learn to do things differently. Portraits of women and children can frequently be made more appealing by softening the lines with diffusion, or soft focus, attachments. The image actually is not out of focus, but the irregular pattern etched into the glass spreads the highlights into the shadow areas and makes fine lines disappear. Older people like this wrinkle-effacing effect. However, the diffusion filter does more than efface wrinkles. It makes colors blend slightly, and if

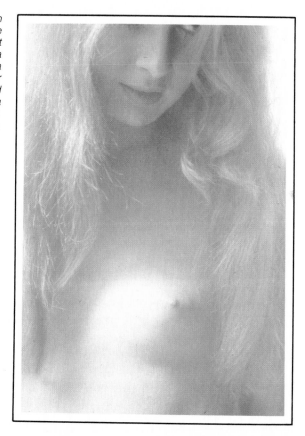

Diffusion effects are often used to romanticize nude photographs. For a shot like this, combine a diffusion filter with a slightly warm-color filter such as a No. 81A, and overexpose slightly for a more pastel color effect. Photo: Courtesy Cokin.

you backlight the subject, the backlight becomes luminous and the picture is rather romantic. It is a lovely filter to use with landscapes, too, to give them a painterly look.

Diffusion filters are available in several strengths, from barely noticeable to quite misty. You can also control the degree of diffusion via the lens aperture. A wide open aperture yields the most diffusion, while small apertures will minimize it.

Fog Filters. The effect of a fog filter is somewhat similar in that it softens the image, but it does so in a way that simulates natural mist or fog. When highlights or bright lights are included in the scene, these will flare and seem to glow. If you want your scene to look like a foggy day, make your photographs when the sky is overcast and the scene is dismal to begin with. The effect can be completely convincing. You can determine just how much fog you want to add by the strength of the filter you choose. Number 1 yields just a slight mist, while number 5 will give you an image bordering on pea soup. For an even stronger effect, combine two fog filters. Generally, a number 3 will be about right.

Technique Tip: Diffusion Effects Without Filters

You do not have to buy diffusion filters to have a diffusion effect. You can make your own. The fastest way to do it is simply to breathe on your lens. Work fast, and the condensation will act to diffuse the image. However, do not try this when the weather is below freezing, as you could damage the lens.

You can also improvise by placing all sorts of translucent items in front of your lens to scatter the light. A piece of cellophane that you have crumpled and smoothed out, gauze, colored plastic, or a tightly stretched nylon stocking (either flesh-toned or colored) all serve to give a diffused effect. You can also try photographing through a very dirty window. With some of these front-end modifiers, you can cut or tear a hole in the center for a center-sharp effect.

Another satisfactory method of diffusion is to smear petroleum jelly on a skylight or UV filter—*never* on your lens. The more jelly you use, the greater the diffusion will be. Spread it all over the filter or leave the center clear, as you wish. Petroleum jelly picks up dust and tends to be messy, so clean it off after you have used it. For a permanent diffuser, dab colorless nail polish over the surface of the filter or on a piece of clear acetate.

You can get plastic fog filters that are graduated, so the foreground will have a light fog effect while the background will seem denser, simulating reality. These come in two strengths, and they may be combined to increase your options.

Fog filters lower the contrast of the scene, just as a grayish fog does. But if you want to maintain the contrast and create a light misty effect, simply increase your exposure by one-half stop.

Some manufacturers call their fog filters "mist" filters; others reserve the term "mist" for a fog filter with color added. You can always combine a color filter with a diffusion or fog filter for unrealistic but lovely effects. Do not be misled by the term "haze filter." This does not add the effect of haze, it eliminates it.

There are a number of diffusion filters with a central, clear area. These can be used to isolate the subject instead of letting it be lost against a busy background. Some of these are colored for a more unusual effect.

Instead of buying many types of filters, make your own combinations. You might put together a center–sharp attachment with a color filter or with a color filter that has a clear central area. You could combine a clear-center color filter with a diffusion filter, or with a diffusion filter that has a clear center. Your through-the-lens metering system will expose the subject correctly unless the filter has a colored area surrounding an uncolored central area. In this case you will have to take a meter reading without the attachment and lock in or remember this setting. Small lens openings and wide-angle lenses will make the clear area smaller and sharper; the opposite happens with large lens openings and telephoto lenses.

Star Filters. Some of the prettiest effects of all are made with star filter attachments. These also add a slight amount of diffusion to the scene. Wherever there are bright points of light, you can create brilliant stars. Put the attachment over the lens, rotate it until the spokes are where you want them, and take the picture. The closer the lights are to you and the darker the background, the more pronounced the star effect will be. If there are no bright lights in the scene, you will merely add a bit of diffusion. You will be able to buy star attachments to produce four–, six–, or eight–pointed stars, and you can combine them for additional points. The attachments are also specified by grid size. Small grids measuring 1–2mm produce more overall diffusion and less brilliant stars; larger 3–4mm grids give less diffusion and brighter stars. The best effects are with f-stops between $f/4$ and $f/8$. Do–it–yourselfers can substitute and experiment with a piece of window screen in place of the commercial star filter.

Star-screen lens attachments turn direct light sources in your pictures into star shapes. They can be combined easily with color filters for additional effect. Photo: Courtesy Cokin.

Masks

MATERIALS AND EQUIPMENT: Matte box, dull black paper or vinyl, .005 matte acetate, Mylar drafting film, gelatin filter holder, vignetting devices, shaped masks, positive and negative mattes, razor art knife with No. 11 or No. 16 blade, opaquing liquid, tripod.

Masks block out part of the subject you are photographing, allowing you to do exciting things with the unexposed part of the film. You can buy masks or you can make them yourself.

Vignetted Pictures. A vignetting effect is the darkening—or the lightening—of the edges of the picture, leaving the main subject sharp. This is somewhat like the center–sharp effect of a diffuser, but instead of the surrounding area being blurred, it is completely, but gradually, eliminated. Several manufacturers make vinyl masks that fit into a holder that attaches to the lens. These black or white masks have a cut-out area in the center. To make one yourself, take a piece of black vinyl, construction paper, heavy matte acetate, or Mylar drafting film, and use an artist's razor knife to cut a hole in the middle. The shape does not have to be a perfect circle; in fact, it is better to make it with ragged edges or completely irregular.

Masked Pictures. You have seen them—pictures that look like they were being viewed through a pair of binoculars or a keyhole. Masks can be used to transform your pictures into something other than a rectangular shape. Make a pattern on a sheet of paper, then trace around it onto a sheet of black vinyl or heavy black paper. You

will have to experiment with the size of the opening. Cut the shaped hole out of the black material and place it in front of the lens.

Here is where a matte box comes in handy. This device is a bellows arrangement that attaches to the lens and lets you insert masks and filters, positioning them at variable distances from the lens. The farther a mask is from the lens, the smaller and sharper the edges will be. When taking the picture, use as small an aperture as possible, at least $f/11$. A normal or somewhat wide–angle lens will also increase the mask's sharpness. As before, take your meter reading before the mask is in place.

Composite Pictures. A similar type of shaped mask, in a matte box, can let you put several images onto one picture. Use it this way:

1. Make a mask with openings on the left and right.
2. Take an exposure meter reading of the subject.
3. Place the mask in a matte box and cover one of the openings with a piece of cardboard or black tape.
4. Make the first exposure.
5. Prepare your camera to make a double exposure (see page and your instruction manual).
6. Position your subject in front of the other opening, block off the first opening, and make the second exposure.

You can also execute this composite technique by using several masks whose openings are in different parts of the picture area, or by using one mask and flipping it from right to left or upside down.

An interesting and surprising image can be made by a double exposure that places one person in two parts of the scene. Your mask is simply a sheet of opaque material that you can slide into the matte box to cover half of the opening.

1. Put your camera on a tripod and take a meter reading. Using a moderate telephoto lens, set an exposure that allows you to use a wide aperture opening, so that the depth of field will be shallow.
2. Position the mask in the matte box so its edge is exactly in the middle of the viewfinder. Use some reference point within the viewfinder to help you align it.
3. Position the model and take the first picture. Prepare the camera for a double exposure.
4. Remove the mask and place it on the other side of the matte box, being careful not to jiggle the tripod.
5. Have your model move so he is seen on the other side of the viewfinder.
6. Take the second picture.

If you lined everything up well, you should not see any line of demarcation in the middle of the picture.

Highlight Modifier. Another intriguing trick you can do with a mask is to change out–of–focus highlights into definite shapes. Candles can look like pinwheels or Christmas tree lights can look like stars. You can buy or make these special masks.

1. Make your mask on a piece of 7.5 × 7.5cm (3″ × 3″) black vinyl or cardboard, cutting out an opening, in the desired shape, that is slightly smaller than the front element of the lens.
2. Put a 100–200mm telephoto lens on the camera.
3. Focus on your subject.
4. Tape the highlight modifier to the lens or put it in a filter holder.
5. Open the lens to its largest aperture and take a meter reading. Adjust the exposure by changing the shutter speed.
6. Make your exposure.

Picture within a Picture. The most sophisticated use of a matte box is to insert one image inside another. You will need a pair of positive and negative masks, which you can buy or make yourself. The negative member of this set is a piece of black vinyl or cardboard with the desired shape cut out of the center. Circles and ovals are always good, but you might want a star, heart, champagne glass, or something more original. The positive mask is identical except that the shape is black and the mask itself is on transparent acetate.

To make the masks yourself, cut a shape out of the black material. Carefully trace the shape onto a sheet of clear acetate, and fill in the outline with black opaquing liquid. When you are ready to take the picture, take a meter reading of the first subject. Put the positive mask in the matte box and make the first exposure. Remove the mask and take a meter reading of the second subject. Prepare the camera for a double exposure. Put in the negative mask and make the second exposure. If things have gone right, you will have two well-defined images with their edges blending into each other. It is best to keep the edges of the pictures soft to allow for any misalignment of the masks. A moderate telephoto lens, large aperture, and the mask close to the lens will do this.

GUIDE TO FRONT-END ATTACHMENTS

Device	Best Aperture	Best Lens	Comments
Auxiliary Fisheye	wide open	50mm	Set aperture on attachment itself; best is 2 or 3 stops less than maximum opening.

(continued on next page)

Device	Best Aperture	Best Lens	Comments
Center Sharp and Vignetting Filters	——	——	Small apertures and/or normal and wide-angle lenses give smaller circles with sharper edges; large apertures and/or telephoto lenses give larger circles with diffused edges.
Close-up Lenses	f/11 or smaller	——	When using 2 close-up lenses, put stronger one next to lens.
Diffraction Filters	——	135mm and shorter; 200mm with "halo" type	For best effects, use against dark background or underexpose ½-stop.
Graduated Filter*	——	——	Larger apertures and/or telephoto lenses give less pronounced demarcation. Smaller apertures and/or normal and wide-angle lenses give more pronounced demarcation.
Highlight Modifier	wide open	100–200mm	Focus without modifier in place. Out-of-focus image will be upside-down if in front of subject, rightside-up if behind subject.
Multi-Image Prisms	f/5.6	50–100mm	Smaller apertures give fewer images with larger spacing between them but with maximum sharpness; larger apertures give more images but they are less sharp. Wide-angle lenses cause images to cluster at center; telephoto lenses spread images to edges. For best effects, use dark backgrounds.
Shaped Masks*	f/11 or smaller	35–50mm	To increase sharpness of mask edge, place as far as possible from lens.
Split-field Lenses	f/11	——	Position subject carefully to mask the split.
Star-Effect Filters	f/4–f/8	Any but extreme wide angle	Larger apertures give out-of-focus appearance to scene; smaller apertures lessen star effect. The closer you are to the subject, the greater the effect.
Super-Wide-Angle Attachments	f/11 or smaller for best image sharpness	28mm for fisheye look (150°); 55mm for wide-angle look (104°)	——
Vignetting Masks*	f/2.8–f/4	85–135mm	The closer the mask is to the lens, the larger the opening will appear and the more diffused the edges.

*Take meter reading without the attachment in place, or use a hand meter.

3

Tricks with Exposure

Photographers usually try to work with a shutter speed that's fast enough to "freeze" the subject's movement. Unless the camera is on some support, most people cannot successfully take a picture using a shutter speed slower than 1/30 sec. But ignoring conventional techniques to create unusual effects is what this book is all about. Shutter speeds of 1/4 sec., 1/2 sec., and longer can create some extraordinary pictures while the subject, the camera, or both are moving.

Special Effects with Long Exposures

MATERIALS AND EQUIPMENT: Tripod, neutral density filter, auxiliary exposure meter.

Blurred Images. You can use a prolonged exposure during the day, as well. This technique makes pictures that convey a feeling of motion or have a romantic, dreamlike quality. Put the camera on a tripod, if you can, or hand–hold it while bracing yourself against a wall or chair. Set your lens aperture based according to the slow shutter speed you will be using. How slow? That is hard to say. It depends on how fast your subject is moving: 1/15 sec. or 1/8 sec. will probably work well, but you should also try 1/4 sec. and 1/2 sec.

On a sunny day outdoors, even a slow film and a small *f*-stop may not let you use a slow enough shutter speed. A neutral density (ND) filter is made just to solve such a problem. These light gray filters come in different strengths and they filter out some of the light striking the film without changing the color.

Blur is the visual indication of movement in a still photograph. The effect here is the combined result of the subjects moving into position and camera movement during a slow hand-held exposure. Use a shutter speed of 1/15 sec. or slower for pictures like this. Photo: G. Kotler.

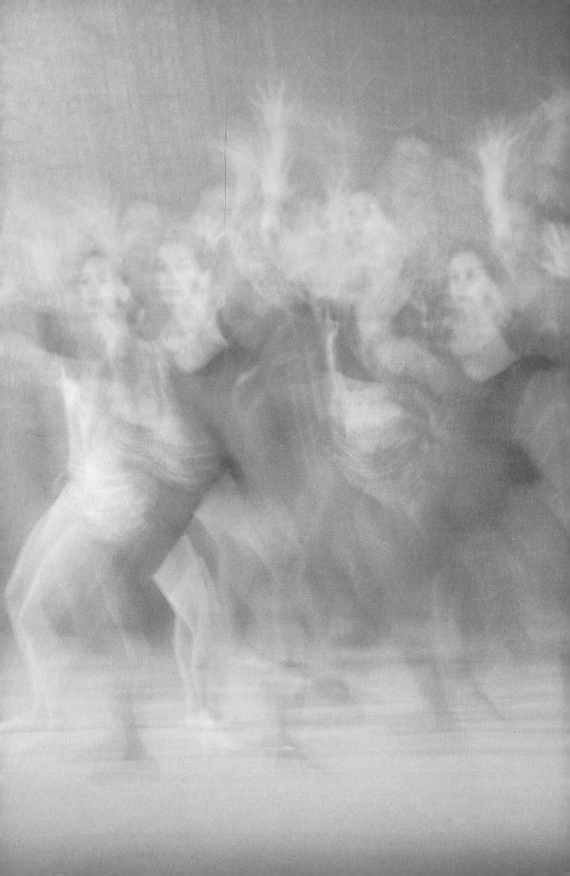

Abstract Images. Here is a fun picture you can make when you are a passenger in a car at night. It is not recommended for the driver!

The procedure is simply to focus the camera at infinity and aim the camera at the road ahead or to one side. If the window is clean, you can shoot through it. Compose the picture so the framework of the window, the windshield wiper, or the car itself does not show. Include as many cars as possible, both coming toward you and moving in your direction. Also, try to include street lights, traffic signals, and colorful neon signs. Or aim just at the neon signs alongside the road, omitting the cars. Close down your lens to about $f/11$ or $f/16$ with an ASA/ISO 400 film, or try $f/8$ with a slower film, but temper your exposure by considering your speed and how close you are to the lights. Set your shutter speed to "B," depress the shutter release, and hold it down for five to ten seconds. A short exposure time will produce short, wiggly streaks of light; longer ones will produce streaming ribbons. Each bump in the road will help add interesting patterns, so do not try to hold the camera rigidly.

A related nighttime exposure is one that requires a tripod and a camera location that lets you look down at highway traffic. You can do this after dark, or start at sunset or while there is still some twilight left in the sky. You may want to use exposure times from ten seconds up to a full minute. Try an aperture of about $f/8$ with a film of ASA/ISO 64. It is best to try a range of times. Too much exposure,

Shoot from a moving car at night for this effect with lights overhead and along the side of the road. Focus the lens at infinity and aim through the windshield. At f/8 or f/11 with a high speed film open the shutter on B for five to ten seconds. Try various exposures to get different effects. Photo: J. Meadows.

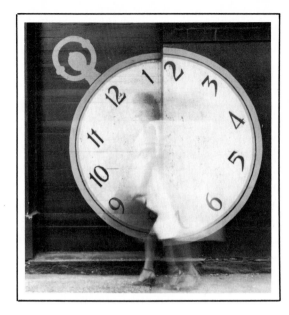

To ensure exact placement of the sharp figure, the photographer positioned the model in front of the clock and then had her step backward during a 1/8 sec. exposure to produce the blur effect. Photo: A. Balsys.

though, can wash out all the color. The car lights will streak into long, continuous lines during this exposure, so position yourself at a place where these lines will curve or make an interesting compositional pattern. If you are using color film, you might want to use a color filter over your lens or even change filters during the exposure.

Vanishing People. For real camera magic, you can make people disappear with the touch of your finger. This technique lets you photograph the inside of a building and have everything except static walls and furniture disappear. A tripod is a necessity for an exposure time of 10, 20, or even 30 seconds. Most meters inside the camera do not indicate these long exposure times, so you will have to use an auxiliary hand meter, or guess.

During this long exposure, the subjects will not remain in one place long enough for their images to register on the film. Judge your exposure time according to how fast the subjects are moving.

There is one other thing you must take into consideration during a prolonged exposure. At exposures longer than one second, color films need additional exposure to record the image properly. They will produce inaccurate colors unless a special color correction filter is used, but this probably will not detract from your picture. This problem is known as "reciprocity failure," and the instruction leaflet packed with the film will tell you how to compensate for it. A film that you intend to expose for two minutes may need an additional two minutes of exposure time as well as a cyan filter. Check the instructions and bracket your exposures. The problem exists to some extent with black–and–white films, but it usually is not serious.

Long Exposure Plus a Short Exposure

MATERIALS AND EQUIPMENT: Tripod, electronic flash, photoflood lamp(s), tight–fitting lens cap, locking cable release, black fabric, auxiliary exposure meter, extension cable for electronic flash.

You can deliberately blur an image, or you can blur it and also add a sharp image of the subject. This will help define the picture for the viewer.

Room Light plus Flash During the Exposure. This method is most effective in a controlled situation, where you can place a model against a black background. Several yards of matte black fabric tacked to the wall makes an easily portable background. The technique requires that you can be close enough to use an electronic flash. You want your subject to be moving—dancing, doing a cartwheel, or any relatively simple movement. Because the light from the flash is strong and of short duration, it will freeze an instant of the action. The light in the room will provide enough illumination to expose the film while the subject is moving. These room lights should not be too bright because you will need an exposure of several seconds and an f-stop that will coordinate with the flash exposure.

If your camera's shutter is set on "B," it will automatically fire a flash connected to the camera when you press the shutter release. When you set off the flash this way, be sure the movement is already in progress before you start the exposure. If you want the flash to fire midway during the exposure, do not connect the flash to the camera. Most electronic flashes have a test button you can use to fire it independently—at any moment you wish.

You will have to do a little calculating. First decide how long you want the exposure to be. Two or three seconds should be about right. Then take a light meter reading to determine the correct f-stop for that shutter speed. You will probably have to use a hand–held meter for exposures longer than one second. For a prolonged exposure, you will have to work in a dimly lit room or else cut some of the light with a neutral density filter. When taking the light meter reading, place the ND filter in front of the meter. The remaining thing to determine is the flash exposure. With an automatic flash there is nothing to figure, since the flash will considerably throw out the correct amount of light when it is set for the appropriate f-stop. With a non-automatic flash, you will have to control the amount of light reaching the subject by the distance the flash is placed from the subject. This distance equals the guide number of the flash divided by the f-stop you have already determined: $d = GN \div f$. Place the flash at that distance from the subject and make it ready to fire. You will have to put the camera on a tripod and set the shutter speed to "B."

Start the model's action, press the shutter release, and hold it down for the desired amount of time. If you want the flash to go off at the beginning, connect it to the camera. Otherwise use the test button.

Technique Tip:

Multiple Exposures with Flash Followed by Photoflood

You can use a flash plus other lights to produce highly controllable movement effects. For this, go into a room that you can completely darken and hang a piece of black cloth for a background. The subject's movement should be a simple one, preceded by a static position. This kind of picture looks best if the movement goes in only one direction, giving the viewer's eye an end point to rest on. You might have the model rise from a seated position or simply walk across the room. Strangely enough, some simple actions like this work best if the subject moves backwards. This is the shooting sequence:

1. Put the camera on a tripod.
2. Set up a photoflood lamp to illuminate your model. Put an electronic flash near the photoflood lamp.
3. Turn on the flood lamp, take an exposure reading, and make note of the correct *f*-stop for a two– or three–sec. exposure.
4. Set the camera for the proper *f*-stop for the flash exposure.
5. Have the model get in position.
6. Turn the lights out.
7. Open the camera shutter on "B" or "T."
8. Make the flash exposure (it will fire automatically if it is connected to the camera).
9. The model must remain in position while you put the lens cap on the camera, change the aperture if necessary, and turn on the flood lamp.
10. The model starts moving as you remove the lens cap and continue the exposure.

It helps to have an assistant handle the lights, but you can do it yourself. Set the camera for a time (T) exposure rather than on "B," if you have such a setting. If not, you can lock the shutter in an open position by using a locking cable release. Of course, you could do this as a double exposure, letting steps 1–8 be the first exposure and 9 and 10 be the second.

If you do these techniques in color, the various types of lighting will render the colors differently. This may not be detrimental, but it is something to consider.

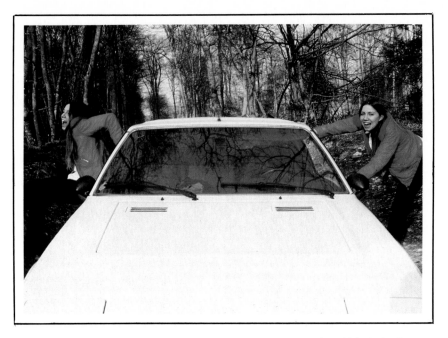

Block part of the image during an initial exposure, then uncover it and block the first portion during a second exposure. This will let you show the same subject in more than one part of the scene. Photo: Courtesy Cokin.

Multiple Exposures

MATERIALS AND EQUIPMENT: Tripod; locking cable release; black cloth; filters: red No. 25, green No. 58, and blue No. 47B.

Not too many years ago, photographers always had to remind themselves to advance the film or they would have two exposures on the same frame of film. Result—two ruined pictures. So the benevolent camera manufacturers designed foolproof ways of preventing this. As soon as double exposures became impossible to make, creative photographers wanted to be able to do them—because *planned* multiple exposures can make exceptional images.

Today there are a few cameras with double–exposure buttons. On other cameras, you usually can double–expose by depressing the film rewind button and cocking the shutter. Alternatively, you can work in a completely dark room, open the shutter on "T" or "B," and fire an electronic flash for each exposure. The "B" setting can be locked open with a locking cable release. The way to learn how to double–expose with your particular camera is to consult your instruction manual.

Separated Images. One way of putting two images into a single picture is to place your subject against a black background. Because black reflects no light back to the camera, the film will not be exposed. You can use that unexposed part of the film for your second or third image.

Take a meter reading of your subject, position him so you see him on one side of the viewfinder, and make the first exposure. Prepare the camera for the double exposure, move the subject to another position, and take the second exposure. For protection against having overlapped frames when double-exposing by depressing the rewind button, shoot off a blank frame of film with the lens cap on. That is all there is to it.

This is an especially nice technique for portraits. You might combine a front view with a profile, or a front view with right and left profiles. You can do three exposures the same way as you do two. If you want to be sure that the images do not overlap, use some mark within your viewfinder as a reference point—the center focusing spot, data indicators, even dust spots.

When you plan superimposed images of the same subject, make them different sizes and from different viewpoints for improved clarity.
Photo: J. Bruehl.

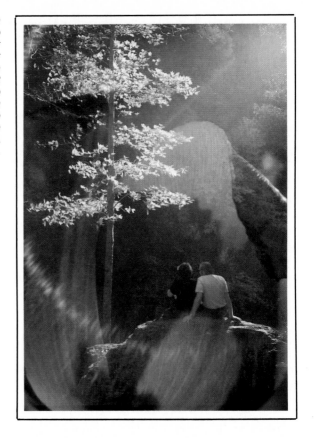

Double exposure is an easy way to add mood to an image. Check your camera instructions for the way to make a double exposure. The most common procedure is to push in the rewind button and hold the rewind knob firmly while operating the film advance lever. Photo: L. Moore.

Superimposed Images. Another method of double exposure is to deliberately allow the images to overlap. Plan where you want them to fall, line each one up in the viewfinder, and make the two exposures. You do not need a black background; in fact, this technique works well outdoors or inside. The difference in the effect is that now both images will overlap and show through each other.

Since the film is being exposed twice—or even three times—the images will be washed out on slides, or overexposed on negatives, unless you adjust the amount of exposure you give the film. For each part of a double-exposure sequence, allow half as much light to strike the film. You can do this either by closing down the aperture one stop or doubling the shutter speed. If you have an automatic camera, set the film speed indicator so it is double that of the film. Remember to set it back again later. For a triple exposure, you must give each picture 1½ stops less exposure. With any camera, it is easiest to do this by tripling the film speed setting.

You can use this double–exposure technique to produce some unusually colored images. Choose a dark subject against a light background. Make two exposures, using a different color filter for each, and changing the camera position slightly between exposures. Or make each exposure with a different setting of a zoom lens.

Tri-Color Effect. You can achieve some beautiful effects on color film by making triple exposures with red, green, and blue filters. When superimposed colors overlap, the effect can be gorgeous. Blue falling on top of red, for example, will turn to magenta, blue and green will turn cyan, and red plus green will turn, of all things, yellow. White light, as you know, is composed of red, green, and blue light. If you make a triple exposure using a red, green, or blue filter for each of the exposures, and if nothing in the scene moves, the picture will look quite normal. But if a white cloud drifts across the sky, it will be recorded with accents of red, green, and blue along with cyan, magenta, and yellow. Try it.

Take your camera out on a day when billowy clouds are moving across the sky, white smoke is drifting upwards, or water is splashing over a waterfall. Put the camera on a tripod, and make three exposures, one each through a 25 red, 61 green, and 38A blue filter. Your exposure setting must take into account the density of the filters and the fact that you are making a triple exposure. Do it by metering the scene without a filter, then setting the camera for *one stop more exposure.* Use this setting for each of the exposures. With a completely automatic camera, set the film speed setting to triple the film's actual speed and let the meter compensate for the density of the filters.

Three exposures, one each through red, green, and blue filters, can give you this effect. Only moving objects will show changed colors. Use the camera on a tripod and give one stop more exposure than the meter indicates without a filter. Photo: T. Kilby/Atoz Images.

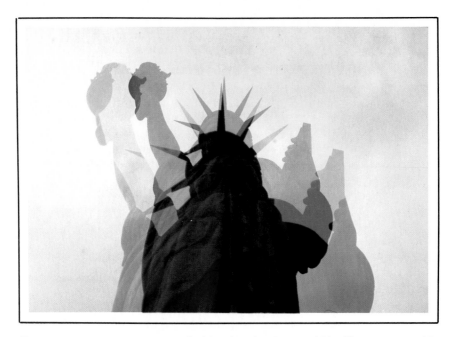

Three separate exposures were made through red, orange, and blue filters to create this multiple-exposure view of the Statue of Liberty. An 80–200mm zoom lens was used at different focal lengths to produce the different sized images. The same effect can be created either by moving the camera between exposures or by keeping the camera stationary and changing lenses. Photo: J. Scheiber.

Multiple Short Exposures

MATERIALS AND EQUIPMENT: Electronic flash, tripod, black background cloth.

There are a number of impressive pictures you can make if your photograph is built up of a series of very brief exposures. You have probably seen photographs made with a strobe light that had perhaps ten or more images of a person in action. Of course, if you have access to a repetitive strobe, you can use it to illuminate a rapidly moving person. But if you do not, you can still simulate the strobe effect. Here are some ideas.

Multiple Bursts of Flash. Work in a room that you can darken completely, and hang up a large, black cloth to serve as a background. You can also work outside on a dark night if you keep your model away from buildings and other objects. Put your camera on a tripod. Your light source will be an electronic flash, preferably one you can connect to the house current. Put the flash either on the camera or off to the side, but do not connect it to the camera. It's best to use a manual flash, since an automatic one will tend to overexpose with the predominately

dark background. Choose your *f*-stop and position the flash at the appropriate distance using the guide-number method described on p. 48. The procedure will be:

1. Position the subject so you see him on one side of the viewfinder, and set your focus.
2. Turn off the room lights.
3. Open the camera shutter on "B" or "T."
4. Have the subject start moving as you fire the flash, and keep firing it as rapidly as it recycles.
5. Close the shutter.

The subject should move from right to left or left to right in a continuous movement, but he should not come toward or away from the camera. His speed should be moderate, but it will be dependent on how fast the flash can be fired. The object is to have the subject in a location that is slightly different yet partially overlapping the previous one. A wide–angle lens will give you room to make more images than a longer lens.

Multiple Exposures with Camera or Subject Movement. You can create a somewhat different effect by working with either the prevailing light or with electronic flash, but this time making a series of separate exposures. This is a multiple–exposure technique that goes far beyond the two or three images talked about earlier. This time you will make as many as ten exposures, and, for each, either the subject or the camera will move just a little bit. You can do more if your patience holds out. The difference between this and the preceding technique is that here there is an overlapping of a great many images.

Use a slow film, which makes it easier to adjust your exposure. All of the images will overlap, so the exposure must insure that the picture is not overexposed. When making a double exposure, it is necessary to halve the exposure for each of the two pictures. For six pictures, each must receive only one-sixth of the total exposure; for 10 pictures, one-tenth.

Multiple exposures: Use dark background and a tripod with a panning head; lock the shutter open. Pan the camera slightly each time after you fire the flash manually. Or, shift the subject each time instead.

Stand your ever-patient model in front of the camera. Although the background does not necessarily have to be black, the picture will be more pleasing if it is. The camera must be on a tripod. Take your meter reading and set the *f*-stop and shutter speed—or let the camera work automatically. Now have the model go through a series of movements, holding each position while you make the exposure and prepare the camera for the next one. The subject should go through a sequence of movements so each position is slightly different. A dancer would be ideal for this, but any person can learn to walk slowly or go through some athletic movements.

If you do not have a patient friend, try a building or a tree. With your camera on a tripod, shoot a multiple-exposed picture. For move-

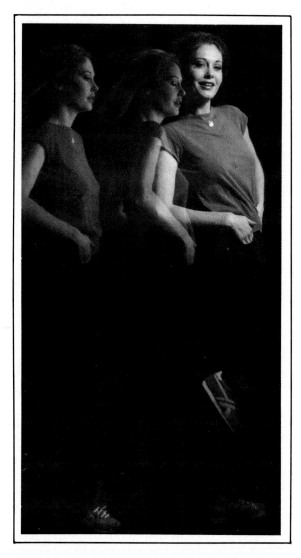

For visual emphasis, give reduced exposure to early positions, full exposure only to final position. Close lens a half-stop or cut flash output to ¾ power for reduced exposures. Photo: J. Alexander.

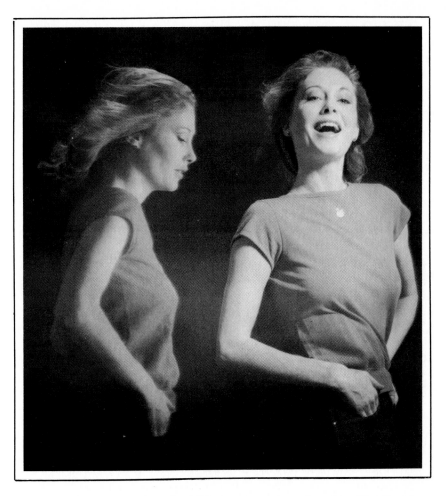

When positions do not overlap, give full flash exposure in each position. Watch out for existing light; with shutter locked open it may cause ghost tone as model moves from between positions, in spite of black background. Photo: J. Alexander.

ment, start with the camera high on the tripod and lower it the same amount between each exposure. You might want to measure and mark the extension column ahead of time with tape or crayon; this will let you move unhesitatingly when you want to change camera position. If you have a zoom lens, you can use that, too, by changing the focal length of the lens between exposures.

Start experimenting with other variations, too. See what happens if you use a multiple-image prism and rotate it between exposures. Or change color filters during a zoom. Or zoom and lower the camera on the tripod simultaneously. It is up to you!

4

Camera Movement

Camera movement can create attractively blurred images, but it can also help keep images sharp. A well–defined subject against a streaked and blurred background unmistakably conveys a feeling of motion. The streaks help the viewer to make an evaluation of the subject's speed, and the more blurred the trees, houses, and background details are, the faster we assume the subject is moving. Cartoonists and film animators add "speed lines" to make sure the viewer knows the subject is moving. Photographers can do it, too.

Blurred lines behind a runner, a rodeo rider, or a car all may be more motion-suggesting than a picture that is crisp and sharp in every detail. You make detail sharp by using a fast shutter speed. But to blur the background, you will have to do the opposite. Shoot with a shutter speed of 1/15 sec., at the fastest, and more likely 1/8 sec. or 1/4 sec. You will probably be shooting outdoors, so you will need as slow a film as possible. On a sunny day even slow film will prove too fast, so try using a neutral density filter or a polarizing filter which cuts out about 1½ stops of light.

If you decide to use black–and–white film, a dense color filter can eliminate two or three stops of light. Unlike a neutral density filter, which will not affect the color of the subject, a color filter will change the tonalities. This can be an advantage. In order for this type of picture to be successful, the subject must contrast well with the background, and a color filter can help achieve that contrast. Choose a filter that will lighten or darken the background while doing the opposite to the foreground. With color film, select your subject wisely. A person wearing a green suit and running in front of green hedges and trees, without sunlight highlighting him, is going to make a drab picture. You need contrast of color or contrast of light, or both. Black–and–white or color, you also must have detail in the background, because it is the detail that will form the streaks.

Rotating your camera during an exposure will produce this effect. If the pivot point is not directly behind the lens axis, the visual center of rotation will not be in the center of the frame, as here. A varied subject such as the sky seen through tree leaves produces a more interesting effect than one composed only of large, light and dark areas. Photo: D. Doody.

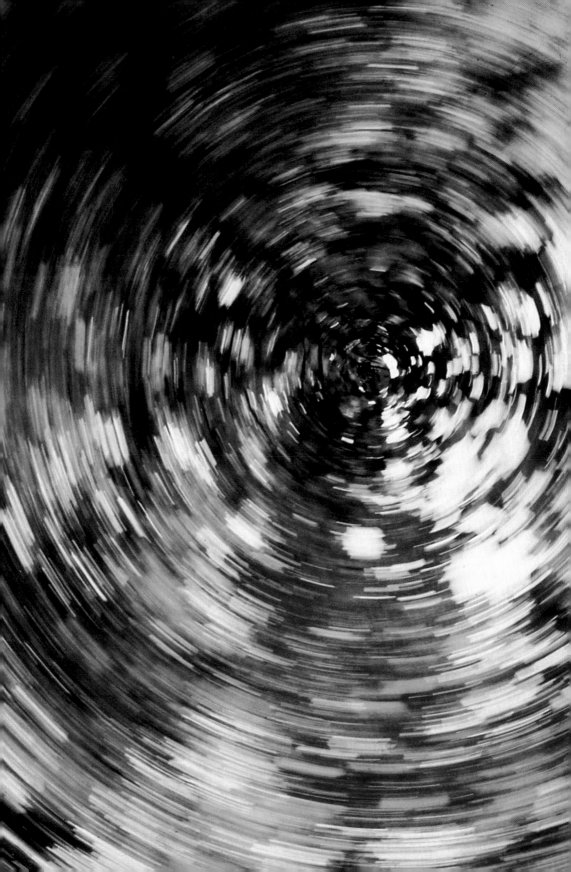

Panning the Camera

MATERIALS AND EQUIPMENT: 0.9 neutral density filter, motor drive or auto–winder.

The technique calls for you to move, or pan, the camera at exactly the same speed and in the same direction the subject is moving. If your movement is synchronized with the subject's, the subject's image will be sharp but your camera movement will blur the background.

Technique Tip: Practice Panning

Panning sounds simple enough, but it does take practice to get the feel of it. A good idea is to practice with an empty camera.

Stand on the sidewalk near a well–traveled street, and aim the camera at the cars that whiz by. For right–handed people it seems to be more natural to move the camera from left to right, but you should learn to do it in both directions. Sight your subject in the viewfinder, and then move the upper part of your body while you follow the subject. You must be moving *before* you press the shutter release, keep moving *during* the exposure, and continue moving *after* you have released the shutter. There must be a continuous flow of movement, and you must fight the tendency to bring your movement to a halt after you have clicked the shutter. The disadvantage of an SLR camera is that you cannot see the subject while you are making the exposure, so it helps to shoot with both eyes open.

The secret of a successfully panned picture is to keep your movement in sync with the subject's. If you have a motor drive or auto–winder, use it. It lets you concentrate on following the action while you make a series of pictures and you'll find yourself automatically panning the camera at the correct speed.

The shutter speed you select will depend on how rapidly the subject is moving past you. Nevertheless, the fastest shutter speed should be 1/15 sec. If it clicks faster than that, you will not have time to move the camera enough to blur the background. If the subject is not moving very fast, try 1/8 or even 1/4 sec. You may have to go to an even slower shutter speed if the subject is some distance away from you. For the best pictures, though, be close enough to the subject or use a telephoto

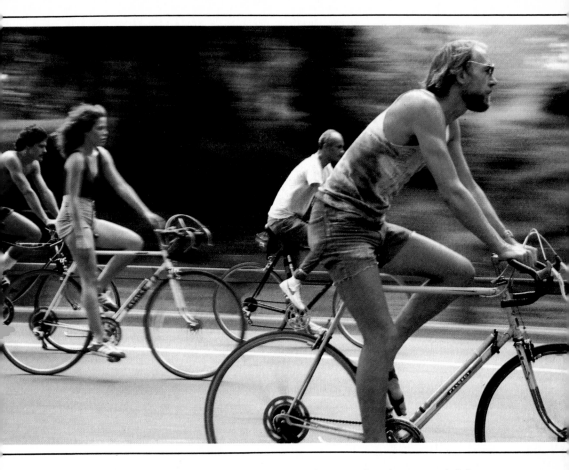

Panning lets you capture motion without the need for a very fast shutter speed. Follow the subject and press the shutter release while the camera is moving. The background will have a streaked appearance, and any slight blur in the subject will enhance the feeling of motion. Photo: D. Cox.

lens so he is fairly large in the frame and not lost in the blurred background.

A way that cannot fail is for you to be riding in a vehicle that is traveling at the exact speed of your moving subject. Photograph other cars from your car, or have your driver pace himself alongside a bicycle rider. It does not seem as sporting this way, but it works.

These pictures will not be as sharp as the frozen motion of a high shutter speed, but that is part of their effectiveness. You can let the subject be even more blurry by deliberately panning a little faster or slower than the subject, still trying to achieve straight, streaked lines in the background.

Horizontal, Vertical, Rotational, and Jerky Movements

MATERIALS AND EQUIPMENT: Tripod, 0.9 neutral density filter, fisheye converter.

Moving the camera is usually a technique left to people with movie cameras. But as you know if you tried panning the camera (as described earlier in this chapter) or traveling with the camera to make abstract pictures of lights (Chapter 3), a camera in motion becomes a creative tool for the still photographer. How many directions can you move it? You can move it to the right or left, up or down, forward or backward, around in circles, or just jiggle it. Exploring these variations can occupy you for days and help you find new ways to capture familiar subjects.

All of these movements require a relatively slow shutter speed for your cleverness to show an appreciable effect. Too fast a shutter speed can freeze your camera movement, just as it will freeze subject movement. More than likely though, it will blur the image just sufficiently to look like a mistake. Too slow a shutter speed may not work either, so in every one of the following suggestions you should repeat making the picture, using a different shutter speed each time. One or even more may turn out to be great.

A sweeping movement upward with the shutter open will give you this kind of effect. The degree of blur depends on how fast you move the camera and how sharply you focused. Photo: P. & L. Hermann

Slow blurring movement in the direction of the major subject dimension—vertically, in this case—will suggest a sense of stretching or growth. Photo: R. Gilbert.

Horizontal Movement. If you have already tried panning with a moving subject, how about moving the camera horizontally past an unmoving one? This way you can impart a feeling of movement where none exists, or you can add an intriguing look to an ordinary picture. Choose a subject with many vertical lines to emphasize the effect, but be sure those lines are not too slender. Very thin lines, like the masts of a sailboat, will disappear when you move the camera.

Vertical Movement. Moving the camera vertically can call attention to the height of a tall building, and this is especially effective if you take the picture at twilight, when the windows are illuminated. Or try this vertical movement with any subject having conspicuous horizontal lines.

It is important that the subject contrasts well with the background. Light areas against dark are somewhat better than the other way around, but try both. With color film, look for foreground colors that are different than the background colors. Try shutter speeds of 1/15, 1/30, and 1/8 sec.

Although you can hand-hold the camera, it is a good idea to put it on a tripod, loosening the tripod head so it will move smoothly. Move

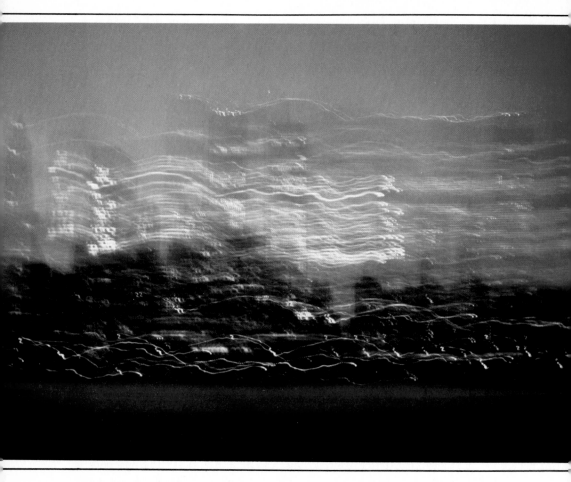

This is the light-trace effect you get by shooting out the side window of a car as it moves parallel with the subject. It is very different from the effect produced by moving toward or away from the subject, shown earlier. Photo: D. O'Neill.

the camera *slowly* upwards or downwards—you want to make a recognizable picture, not a complete blur. Try shutter speeds of 1/8, 1/4, and 1/2 sec. to give you enough time.

Jerky Movement. Smooth, fluid movements of the camera are nice, but do not be afraid to try hand–holding and jiggling it in an abrupt manner. The result of such heavy-handed treatment will be an abstract photograph that looks best on color film. The best subjects are colorful ones against a dark background. A neon sign, building lights, or several objects of different colors set in front of a sheet of dark paper all are good to photograph. You will want to isolate the subject and make it unrecognizable. Come close to it or use a telephoto lens. A shutter speed of 1/15 sec. or 1/8 sec. should give you time enough to

jerk the camera. You may want to underexpose slightly to produce more saturated colors. If you wish to use a tripod, just before you press the shutter release, bump the tripod. Press the shutter release and bump the tripod again during the exposure. Crazy—but effective.

Rotational Movement. Do not limit yourself to moving the camera in a straight line. Try rotating it. You can do this two different ways for two types of effects. One idea is to stand under a clump of trees or in a room where there is something of interest hanging from the ceiling. Point the camera upward and twirl yourself around while making the exposure. Move slowly enough so the image will have curved trails rather than being a complete blur. A fisheye-type lens is appropriate for this.

At night, you can try another type of rotational picture, using anything with bright points of light as your subject. A building, a bridge, a Christmas tree, or any group of lights can photograph well. Face the subject normally, and when you make the exposure, move the camera so it describes a small circle. If you shoot from a distance, the light will form a circular or, more probably, a spiral pattern. Too close, and the lights will be bright blurs. You will most likely be using a wide-open lens and a shutter speed of about 1 sec., but try various apertures. Start the movement before you press the shutter.

Experiment with many kinds of camera movement. The overall pattern is established by the sweep of the movement; jittery variations result from the unsteadiness of holding the camera by one hand as you move it. Photo: W. Updike.

Zooming

MATERIALS AND EQUIPMENT: Zoom lens, tripod, special effects prism attachments.

A zoom lens is usually used to obtain a variety of focal lengths without needing to change lenses. But there is another use called zooming, in which you move the lens through the different focal lengths while exposing the film. This is done all the time in motion pictures, but rarely in still photography. A zoom image made with a still camera will produce diagonal streaks that seem to radiate from the center, while leaving that central part of the image almost sharp. The image seems to explode with excitement and movement.

You must put your camera on a tripod to be sure that only the zoom mechanism moves during the exposure. For your first attempts, choose a static subject, like a brightly lit building at night or a friend sitting in front of a clump of trees. After you get the feel for it, try focusing on someone or something that is moving toward you.

Choosing a Subject. The various tones, colors, and details change in position during the zoom to create the streaks, so you must look for a background that is busy. Standing your model in front of a blank wall will not do—you need something with pattern. On black–and–white film, the elements of light and dark will produce good streaks. On color film, the more color in the background, the better. As with many things about special effects photography, this is exactly the opposite of what you customarily would do to make a good picture.

If the subject is large, like a building or a close–up of an object, the outer areas of the subject itself will become streaked, while anything in the center will remain relatively sharp. When you are filling the viewfinder with a single subject, make sure there is detail on the sides, top, and bottom.

Place the subject carefully so what you want to be sharp will be sharp. If you have a focusing circle in the middle of your viewfinder, that makes an ideal reference point. You can make the entire subject or just the key part fit within it.

In zooming, sometimes the streaking lines diffuse into the dark area and need additional exposure; with other subjects, light areas pile up on top of each other, needing less exposure. Therefore, as usual, it is best to bracket your exposures.

Changing the focal length of a zoom lens during a long exposure can add a sense of motion to a stationary subject. Photo: T. Tracy.

Executing the Zoom. You can zoom from a wide–angle position to the telephoto position or vice versa. The effects are slightly different, so try it both ways. Because the center of the image may shift during the zoom, focus and position the subject at the telephoto position.

Give yourself enough time to execute the zoom. A 1-second exposure is about right for a lens with a 2:1 zoom range (one whose focal length at one end of the zoom range is twice that at the other position). With longer zoom ranges, you may need a longer exposure time. You can zoom slowly, fast, or in jerky steps. The effect in each case will be completely different.

Steady hand-holding is relatively easy while zooming during a long exposure. With night lights, the image seems composed of carefully drawn luminous traces. Photo: B. Docktor.

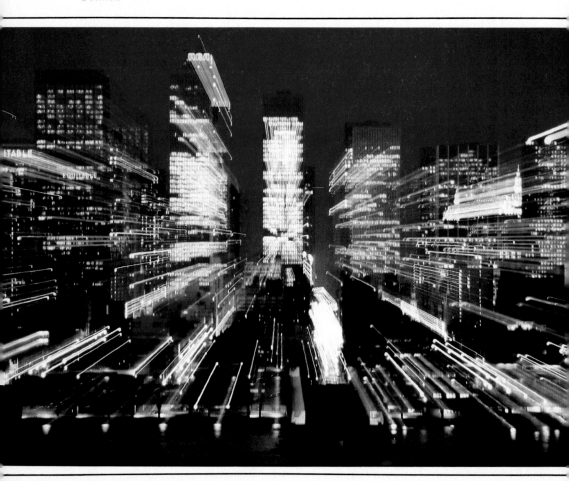

Modern zoom lenses are complex optical instruments. The focal length of this 10-element lens ranges from 24 to 35mm as the positions of the elements change in relation to each other.

Technique Tip: Varying the Zoom Effect

You will be able to vary the effect by the way you begin and end the shot. You can:

1. Start zooming before you press the shutter and continue zooming after you end it.
2. Hold the subject static at the beginning of the exposure and then start the zoom. Generally, you will want to hold it static at the telephoto position.
3. Start zooming before you press the shutter release and hold it static at the end. (With steps 2 and 3, vary the amount of time given to the static part of the exposure.)
4. Hold it static at the beginning and at the end of the exposure.
5. Fire an electronic flash while doing a continuous zoom.

 If these variations are not enough, add one or two multi-image prisms and rotate them during the zoom. Add a color filter. Hand-hold the camera. Zoom and pan at the same time. No other single technique offers so many creative ways to express yourself.

5

Tricks with Lighting

You can create color—unusual and unexpected color—by modifying the light source. Instead of using a colored filter over the camera lens, see what happens when you put one in front of your lights. The effects will be different and you will have a great deal of control over your results. Either photolamps or electronic flash is suitable.

Coloring the Light Source

MATERIALS AND EQUIPMENT: One or more electronic flash units, photolamps, colored acetate, filter–holder frames, lamp stands, electronic flash slave units, electronic flash remote sensor.

Photolamps. The advantage of using photolamps is that you can see exactly where the colored light falls. You can easily adjust the position of the lamps and take your exposure meter reading directly from the subject. You must use colored acetate (or polyester filter with tungsten halogen lamps) made especially for this purpose, in order to withstand the heat of the lamp. Place it about 45cm (18 in.) in front of the lamp. There are frames made especially to hold the acetate which clamp onto the light stand. However, any sort of clip—or even the hands of a cooperative assistant—will work, as long as you leave space for air circulation between the lamp and the filter.

Starting with one light, choose a color that will intensify the color of your subject or will completely alter it. Look through a piece of the colored acetate to get an idea how the colored light will affect the colors of the subject. Of course the more lamps you use, the more color you can introduce into your photographs.

You can get multi-color effects by using several light sources, each fitted with a different color acetate filter. You may not be able to work on the scale of a public monument, like this, but the principle is the same. Continuous-light sources are easier to use than flash because you can see just where each color strikes the subject. Photo: D. Gray.

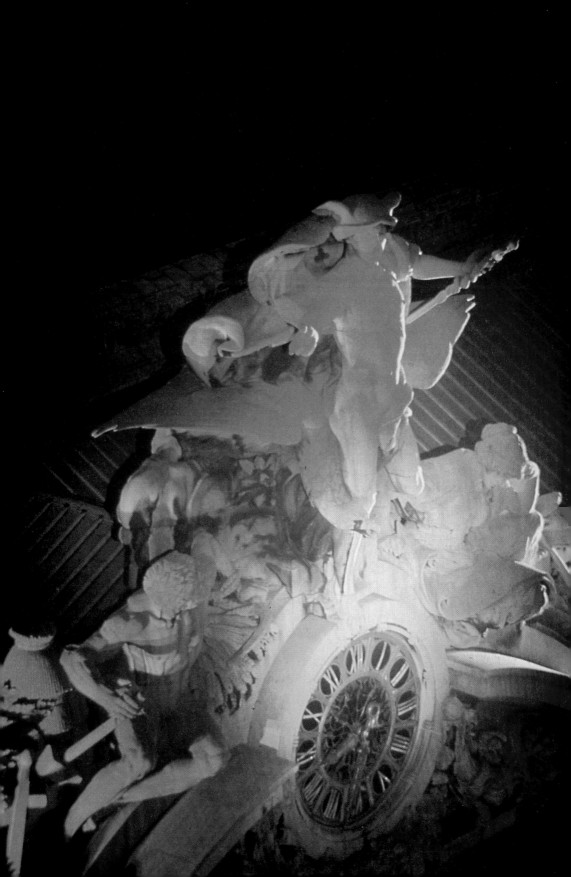

Electronic Flash. Electronic flash is easiest to color. Some manufacturers equip their units with an adapter and filters. If your unit does not have these, get some small pieces of colored acetate. While you can buy acetates specifically intended for coloring lights, any richly hued acetate, or even cellophane, will do. You can buy acetate in art supply stores. Cut a small piece of acetate and tape it over the front of the flash with a bit of transparent tape. Be sure the acetate does not cover the sensor of an automatic unit.

If you are outside with the subject in front of a well-lighted background, or sky, a flash will color nearby objects but it will have no effect on objects far in the background. When calculating your exposure, be sure your shutter speed is appropriate for flash exposure. This is generally not faster than 1/60 sec. Automatic units will compensate for the light loss through the filter, but with a manual flash, allow about one stop extra exposure.

Another interesting idea is to place the colored light on one side of the subject so color will illuminate part of the subject while natural light fills in the other areas. If you are using an automatic flash, it is preferable to use a remote sensor to measure the exposure at the camera. Or put the flash on "manual" and you can control the intensity of the color by adjusting the distance of the flash to the subject.

Two Lights. By using two lights, each with a different color filter, you can have different colors in the background and foreground or have multiple colors playing over the surface of the subject. A slave unit attached to one of the flash units will enable both of them to fire simultaneously. For the first effect, place one of the lights on, or close to, the camera so its light will color just the foreground subject. Put the other light out of view of the camera and directed toward the subjects in the background.

To make multicolors, place a light on either side of your subject. This will throw a different color on each side of the subject, but there will also be a third color where the lights overlap. Blue light on one side and red on the other will give a magenta hue in the middle; red on one side and green on the other will produce yellow in the middle.

Filtered Flash and Camera. A somewhat complex trick is to use complementary color filters over the camera lens and a flash unit. This will change the color of the background while leaving the foreground completely natural. Complementary colors are those which will combine on film to produce the effect of white light: yellow and blue, red and cyan, magenta and green. Cokin specifies the exact ones to use if you are working with their filter system. This is something to try outdoors to color a bright background of sky or buildings.

Put a filter over the lens to change the color of the background. Then put the complementary color over the flash. This will neutralize the effect of the camera filter on the nearby foreground objects. Use manual exposure for both the flash and the camera. Take your meter

reading of the bright background with the filter over the lens, and set the *f*-stop and shutter speed accordingly. Using the guide–number method, determine the distance of the flash, but place it closer to the subject to compensate for the filters. The exact distance will depend on the density of the filters, as well as a little trial–and–error shooting.

Three colored spotlights—red, green, and blue—were used to illuminate a cut onion. The glass table upon which the onion was placed also reflected color from the lights. Photo: K. & I. Bancroft.

Unusual Light Sources

MATERIALS AND EQUIPMENT: Candle, flashlight, slide projector, colored acetate, tripod, exposure meter, high-contrast patterned slides, shaped masks, pictorial slides.

Sunlight; electronic flash, and photolamps are the traditional sources of light for photography, but special effects work often breaks from tradition. Any light that is bright enough to see by can be used to expose film. These more unusual light sources generally are weak in intensity and therefore require long exposures, sometimes as much as 15 to 30 minutes. Although the color of the light may look white to the eye, it often records differently on film, a fact that provides an interesting challenge.

Photographing by Moonlight. Take your camera outdoors on a bright night and you can use moonlight to photograph your house or the landscape. Use a fast film, daylight balanced if you are using color film. A tripod is essential because even a full moon is no rival for sunlight, and half and quarter moons are progressively dimmer. Snow on the ground is helpful because it will reflect light and enable you to use shorter exposure times.

Existing light at night is often quite directional. To emphasize its outlining effect, expose to register the sky as black. That's almost inevitable when you shoot to stop subject movement. Photo: B. Bennett.

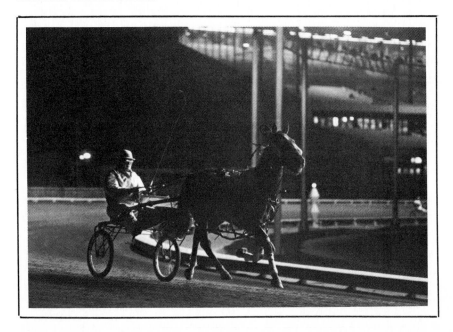

With this kind of subject, expose for the lighted reflections if you can get a spot reading; bracket widely. The warm gold tone that daylight-type color film produces from tungsten light is very effective here.

If you have a light meter that indicates long exposure times, use that to determine your starting point. Otherwise, try the following exposures with your lens wide open: ISO/ASA 400—8 seconds, ISO/ASA 200—15 seconds, ISO/ASA 100—30 seconds. The important thing is to bracket—double the exposure time and halve it. Use shorter exposures for snowscapes and longer ones when the moon is not full.

You may even want to make exposures that are several minutes long, especially with distant landscapes. Surprisingly, the effect may be more pleasing if you do not give the film a completely adequate exposure. A long exposure will look like it was made during the day, and the special effect of the dark, night sky will be lost. Try not to include any nearby bright lamps in the picture because they will cause halation (a halo around a bright spot in the image). If you have to include them, consider putting a star filter on your lens. Distant lights are fine and will help the viewer to realize the picture was taken at night.

There will be a slight color shift with these long exposures, which probably will not detract from the picture. If you want to correct for it, the instruction leaflet packed with the film will suggest an appropriate filter and additional exposure time to use.

Pack a small flashlight with your camera equipment. Unless you have the eyes of a cat, you will need it to read the settings on the camera. It will be hard to focus through the camera, so it is best to estimate the distance and set the lens accordingly, or position yourself so the "infinity" setting is appropriate.

For dramatic mood, let light from a single source pick out subject highlights in dark surroundings. Reduced exposure with window light produced these deep colors and shadows. Photo: H. Hoefer/APA Productions.

Streetlight Illumination. Try other subjects outdoors, too. Stand someone under a streetlight and let that be the source of illumination. If the person is reading a newspaper, it will reflect light onto his face. Beware of the strange color casts those bluish mercury vapor and yellowish sodium vapor lamps give. Floodlit buildings and monuments usually have enough light to let you go as fast as 1/15 sec. at $f/2$ on high-speed film, unless the lights are colored. Use that tripod—or brace the camera on a ledge or post—and take a meter reading close enough to the subject so the dark sky will not mislead the meter.

Unusual Indoor Light Sources. Indoors, there are other light sources you can use. Turn on all the roomlights, use tungsten–balanced film, and you can take pictures without a flash. With ISO/ASA 400 film, you may even be able to use shutter speeds as fast as 1/30 sec. Be careful that you do not let your exposure meter be fooled by having a lamp be too close to it. It would be best to use an auxiliary light meter.

For some unusual pictures, use a candle or a birthday cake full of candles as your light source. Place your subject close to the candle and take your meter reading from the person's face.

If you would like to spotlight a subject, take out your slide projector. It makes an ideal light source when using tungsten–balanced film. You can color the light by placing colored acetate over the lens, or better yet, by shooting slides of pure color and putting them in the projector. You can also place pieces of colored acetate in slide mounts. If you have access to two slide projectors, you may use them to create multi-colored illumination.

Slide projectors offer boundless ways of creating unusual lighting effects. Try photographing patterns on high-contrast film and projecting them over the subject. Or cut shaped masks out of black paper, insert them in slide mounts, add colored acetate if you wish, and focus them sharply on the subject. You can achieve a lovely effect by projecting a colorful pictorial slide as a background for a subject, be it a person or an object. This may work best if the slide is slightly out of focus.

Slide projectors can be used for a variety of effects. Here, a patterned slide was used to project the lines onto the subject's face. A single-color slide will produce a better color spotlight effect than a filter in front of the projector lens. Photo: E. Stecker.

Painting and Drawing with Light

MATERIALS AND EQUIPMENT: Tripod, locking cable release, pocket flashlight, electronic flash, reflector photolamp, sparklers, 1-meter (3-foot) cord, colored filters, black cardboard.

Suppose you are outdoors at night with no moonlight, no street-lights, and a subject that is too large for your electronic flash to illuminate. Or maybe you want to photograph the interior of an enormous room, or illuminate a small subject and not have it cast any shadows. Do not despair. Simply do your lighting in sections with a light source you can bring close to the subject.

Painting with Light. Put the camera on a tripod. Do not connect the flash to the camera, but plan on firing the flash with the "test" button—the "open flash" method. Instead of making one flash exposure, you will make several, each illuminating a different part of the subject but not overlapping the previous one. Either you or a helper will hold the flash, fire it, then move to a new position and fire it again.

This is repeated until you have covered each section with a burst of light. Although it is exposed in sections, the subject will appear evenly illuminated in the picture. The person holding the flash should wear dark clothing so there is no chance of his image being recorded as he moves in front of the camera.

Set your camera for a time exposure. If it does not have this setting, put it on "B" and keep it open with a locking cable release. The correct f-stop is the one that is appropriate for a single burst of the flash. Because the successive flashes will not overlap each other, this setting will be correct.

This technique is called "painting with light" whether you use an electronic flash, or a continuous source of light. If you use a continuous light source it seems more like painting because you actually sweep the light back and forth over the subject without overlapping a "painted" area. Be sure to stand so that your body does not come between the light and the camera. Admittedly, determining the exposure is difficult. It is best to use negative film material rather than slides since minor exposure problems can be corrected in printing. The correct f-stop will depend on the intensity of the light and how fast you are moving it. You certainly should do it several times so you can bracket the exposures.

Drawing with Light. Painting with light uses the light to illuminate the subject; "drawing with light" uses the light itself as the subject. One way to do it is to have a friend stand in a darkened room, holding a flashlight, candle, or a sparkler so it faces the camera. Make a time exposure while your friend creates a picture with the light. He can write a word in script, make abstract squiggles, draw a simple picture, or dance around while holding the light. If you wish, add the

Painting with light lets one small light source do the work of larger, more complex equipment. During the 30-second exposure for this picture an electronic flash unit was fired several times at the church. The ghost image of the photographer's legs in the open gateway show he stayed too long in one spot. Existing light provided the foreground exposure. You'll need a sturdy tripod, and a locking cable release to hold the shutter open on B. You can use a floodlight instead of flash, but keep it moving over the subject. Photo: D. Mansell.

image of the subject by firing a flash sometime during the exposure (see Chapter 3). You can make a flash exposure of the subject and then use a light to draw an outline around him, put a halo over his head, or make it appear as if he is holding something in his hand.

If you suspend a penlight or flashlight from a hook in the ceiling, the unending patterns of light can make fascinating pendulum pictures. Using a regular flashlight, make a more concentrated spot of light by masking it with a piece of cardboard that has a round hole punched in the middle. Place the camera on the floor, preferably on a small tripod. Suspend the flashlight so it is 1 or 1.5 meters (3 or 4 ft) above the camera, centering the lens under it. Use a wide–angle lens if you have one, to insure that you capture all of the moving image. A right–angle viewing attachment on the camera makes it possible to check how far you may swing the pendulum.

Set the aperture to $f/5.6$ with ISO/ASA 125 film or $f/8$ with ISO/ASA 64 film. Turn off the room lights, switch on the flashlight, and set it in motion; then open the shutter for a few seconds. You will want to try various exposure times, starting with a few seconds and going up to several minutes. Also, bracket one f-stop both ways.

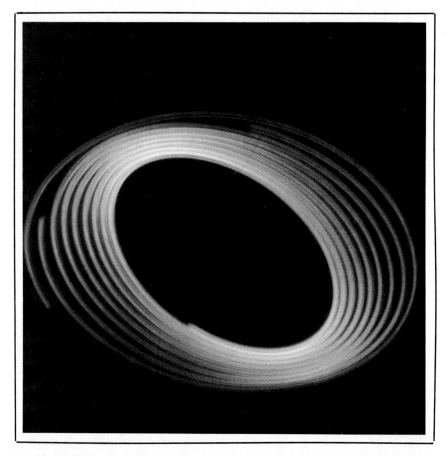

(Left) The basic set-up for making pendulum light-trace pictures. Hold the shutter open on the B setting. (Opposite page) One of the images produced by this set-up. For effects with color film, put a colored filter over the camera lens.

 Technique Tip: Variations on Painting and Drawing with Light

Besides varying the exposure, try some other variations.

1. Interrupt the exposure by placing a piece of black cardboard on top of the lens. During this time, change the direction of the pendulum's motion. Then continue the exposure.
2. Place the camera so it is not centered directly under the light, or change the position of the camera during the exposure. Cap the lens while you move the camera.
3. Lay a colored filter or piece of acetate on top of the lens, perhaps changing filters during the exposure.
4. Use multiple-image filters over the lens.
5. Use two strings of different lengths, attached to separate hooks, and connected in a Y–shape to the flash-light.
6. Cut holes or slots in 7.5 × 7.5cm (3″ × 3″) pieces of black cardboard. Place one of these masks over the lens and leave it there throughout the exposure, or move it, rotate it, or change to a different mask. Color the slots with acetate for another variation.

Shooting with Ultraviolet Light

MATERIALS AND EQUIPMENT: Ultraviolet lamps, ultraviolet-barrier filter, tripod, fluorescing subjects, fluorescent colorants, black background cloth, electronic flash, ultraviolet-transmitting filter, slide projector.

Black light or ultraviolet radiation is invisible to our eyes, but if you shine it on certain objects, it will cause them to give off visible light that can be photographed. The colors are rich and the effects can be startling.

Light Sources. To do it, you will need a source of black light. Most of these look like long fluorescent light tubes, but they are a deep, purply blue color. You can buy just the lamp and fit it into a fixture you already have, or you can buy a complete unit. One manufacturer sells a 38cm (15-in.) unit with an aluminum reflector that intensifies the light. You will also find 46 and 61cm (18- and 24-in.) units at stores that sell psychedelic posters. The major lamp manufacturers make the black light lamp, which is coded BLB. These emit only long-wave radiation and filter out the short wavelengths that are harmful to the eyes. Do not buy black lights that are shaped like incandescent lamps as these emit too much visible light to work well. A 22cm (2⅞-in.) ultraviolet transmitting filter is available that can be taped over a slide projector lens, enabling you to use that as a source of ultraviolet light.

There is still one more source of black light you might experiment with. A No. 18A filter over your electronic flash will give you a black light source that can capture a colorfully costumed person in motion.

There are hundreds of things that will fluoresce under black light, and many of them are already in your house: your teeth, white cotton film-handling gloves, many fabrics and plastics. Turn on your black light and walk around the darkened house—you will be surprised at what is lurking in your child's toy box or in your closets. Labels printed with high-intensity colors, petroleum jelly, powdered detergents, and electrical wires all may fluoresce.

Making Things Fluoresce. If you have something specific you want to photograph and it does not fluoresce, you can make it do so. There are opaque water–based fluorescent poster paints for use on cardboard and paper. Lacquer-based paints will adhere to metal, plastics, and even fabrics. Since these paints are transparent or semi-opaque, they must be used over white or light-colored surfaces. This may make it necessary to start with an undercoating of white. In using lacquer colors on fabric, you can brush the paint onto white cloth and then applique that onto the costume. To cover a broad area very quickly, use an aerosol spray can of transparent paint. It is best to do your painting under an ultraviolet light to check your artistry as you

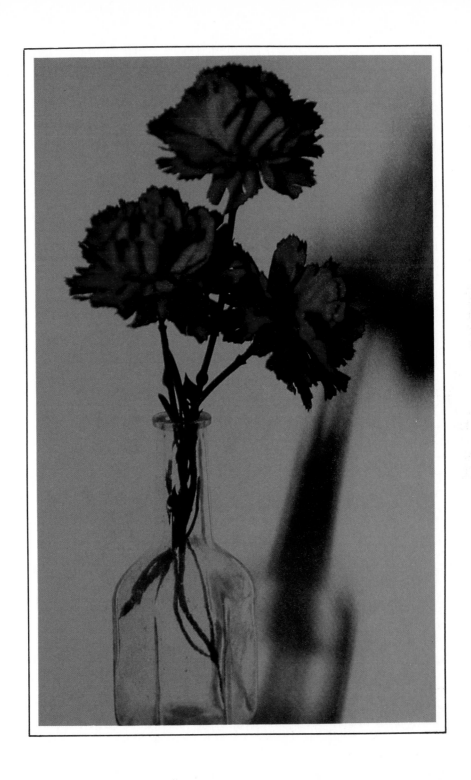

A mixture of visible light and ultraviolet were used here. Only the background responded to the UV to produce this fluorescent blue. Photo: E. Stecker.

Only UV illuminated this puppet; all visible light was blocked. The fluorescent colors of the paints and dyes are quite different from their appearance under white light. Photo: E. Stecker.

progress. If that is impractical, you will certainly want to inspect your work at frequent intervals.

There are other colorants available in art stores and from manufacturers specializing in ultraviolet products: crayons, chalks, felt markers, pencils, inks, oil paint in stick form, makeup, and concentrates that can turn an entire swimming pool into a fluorescent arena. There are colorants to coat tight-fitting garments and specially-formulated dips for feathers. You can fashion spectacular costumes from fluorescent fabrics that are available in solids, prints, ribbons, feathers, fringe, sequins, even hula skirts and buckets of glitter. Stationery and art stores have other fluorescing items such as gift-wrap yarn, large sheets of poster board, rolls of paper, pressure-sensitive paper tape, and modeling clay.

Choosing the right colors is important. The lighter, brighter colors are most intense. Yellow and chartreuse can be especially successful. Light blue is more visible than dark blue, just as pink stands out better than red. Fluorescing objects are actually sources of light, and objects can reflect their color onto nearby objects, usually with attractive results.

The visible light emitted from the fluorescing object also contains a small amount of ultraviolet radiation. This will give the image a slightly bluish cast unless you filter it out with a UV–barrier filter over your lens. A 2A, 2B, or 2C filter is the best to use.

Still–life set-ups make excellent subjects for fluorescence photography. Glassware works well, especially when filled with a fluorescing liquid. Mix water with a bit of fluorescent watercolor paint or grate some fluorescent chalk and pour water on top of it. Accent the top edge of the glassware with petroleum jelly or a bit of paint. Color all sorts of objects with the paint and arrange them on a black background or on another fluorescent material.

Try ghost–like pictures of people made up with fluorescent cosmetics or ordinary petroleum jelly. Apply the makeup under the UV light. Use it liberally and rub it in well, or the appearance will be blotchy.

Technique. Set your subject against a dull, black background. The most satisfactory lighting arrangement is two lamps placed 30 or 60cm (1 or 2 ft) away from the subject and at 45–degree angles to the camera–subject axis. You can use one lamp if you intensify its output by curving a sheet of aluminum foil behind it. Use a high–speed color film, such as Ektachrome 400. Determine your exposure much as you would with ordinary light. Turn off the room lights, come close to the subject, and take your meter reading through the camera lens with the barrier filter in place. Make sure the camera sees only the fluorescing subject and is not influenced by the black background. To play it safe, bracket your exposures.

Silhouettes

MATERIALS AND EQUIPMENT: Bedsheet, photolamps, colored filters, colored paper.

A silhouette is a picture without any detail—just a filled-in outline of the subject against a background. Most people think of silhouettes as a black subject against a white background, but it does not have to be that way. Subjects silhouetted against colored backgrounds, like buildings against a sunset or against fully–detailed backgrounds, also qualify. So do colored subjects against a white or colored background. As long as the subject looks dimensionless and featureless, it is a silhouette.

Technique. You can make silhouettes indoors or outdoors, and both are uncomplicated procedures. All that is required is for you to choose and pose your subject thoughtfully and expose it correctly. The technique is to backlight the subject—that is, instead of letting the light fall on the subject from the front or the side, where it will illuminate all the details of the subject, place the light totally *behind* the subject. Outdoors, it is best to shoot early or late in the day, when the sun is low on the horizon. You can also control the placement of the light if your subject is in a shaded foreground area with a bright area behind it. Such a situation exists where the subject stands in a passageway, doorway, or within a grove of trees. Frequently there are distracting elements in the background instead of the clear area you want. In this case, sit or lie on the ground and shoot upwards, silhouetting the subject against the sky.

Take your exposure meter reading from the light background area. With black–and–white film you may want to open up an additional stop or two to keep the background from registering gray.

When and What to Silhouette. Sunset or sunrise are ideal times. Not only does the sunset make the silhouette, but the silhouette actually improves the appearance of the sunset. The sunset (or sunrise) may be gorgeous to look at, but to emphasize its beauty in a photograph, it helps to silhouette something against it.

Nighttime can be an easy time to make outdoor silhouettes, using a lighted building or store window as your source of illumination. Indoors if you photograph your subject against a window on a bright day, exposing for the light outside, you will get a silhouetted image, or you can simply tack a bedsheet in the doorway between two rooms, darken one side completely, and illuminate the other. Be careful not to throw a hot spot—a more brilliantly illuminated area—in the center of the sheet. Have your subject stand in the dark room in front of the sheet. Another set-up is to use a white wall or a projection screen in a dark room. Aim your light(s) at the wall and place your subject so that it does not receive any illumination. You can do a semi–silhouette—one

Backlighted subjects are easy to silhouette. Meter only the background—the sky in this case—and expose as indicated. The greatly underexposed foreground subject shapes will go black. Photo: M. & C. Werner.

that has a slight amount of detail—by placing your subject in front of a curtained window during the day. Some of the window light will be reflected by the walls of the room, so that you will keep some detail in the subject.

So much for set–ups. The subjects and how you pose them are equally important. Look for distinctive and recognizable outlines. Place people so they are profiled and give them interesting props to hold or hats and elaborate costumes to wear. Isolate trees and flowers so that one does not stand in front of the other and confuse the picture.

When photographing a skyline, look for a variety of heights and shapes rather than a monotonous row of buildings at the same level.

Variations. There are a few creative variations you can do when you make your silhouettes. When using a plain white background, you can color it by placing a filter over the lens. If you want the silhouetted subject in color, make the first exposure in the normal manner and then double-expose the film to a sheet of colored paper. The silhouette

Natural framing elements are an effective way to set off a silhouette. Simplicity is a hallmark of a good silhouette; show basic shapes from an angle that makes them easy to recognize. Photo: B. Docktor.

Recording some detail in shadowed areas produces a strongly graphic image that calls less attention to itself than a full silhouette. Simply give about a half-stop more exposure than you would for a full silhouette. Photo: B. Docktor.

will then become the color of the paper. You could also make the double exposure to a textured or patterned material. Another effect is to make the first exposure with a colored filter on the lens and the second exposure to a sheet of colored paper. The picture will show the silhouette in the color of the paper and the background will be the result of the photographic blending of the two colors. The black area of the silhouette can also be double–exposed with a more conventional picture, or you can take the negative into the darkroom and double-expose it with another negative when you make the print.

6

Tricks for Reflecting and Distorting the Image

Photographing reflected images is an exercise in learning to see. As you become aware of the possibilities that are around you, you will find more and more to photograph.

Found Reflections

MATERIALS AND EQUIPMENT: Mirrors, water, windows, and any other shiny substances that will reflect an image; close–up lens.

Mirrors. Mirrors are the most obvious reflectors. You owe it to yourself to experiment with both large and small mirrors. They are the easiest way to make a self–portrait. With a little practice and a slightly wide–angle lens, perhaps 35mm or 43mm, you will be able to hold the camera away from your face so you do not appear as a one–eyed monster partially hidden behind the camera. You do not have to confine yourself to mirrors hanging on walls—look above and below. Ceiling mirrors, mirrored columns, and shiny floors lend themselves to making unusual portraits. You can photograph only the reflected image or you may want to include part of the room and the frame of the mirror.

Water. The loveliest effects of all can be created by a subject reflected in water. On calm days, a small body of water will give a mirror–like reflection. If you do not want it placid, toss a stone into the water and let the ripples break up the image, or wait for a windy day so the turbulence will distort the image into an abstract pattern.

Look for reflections on the street after a rainstorm. This is especially exciting at night in an area lit by colorful neon signs. In the daytime, the iridescent hues on a layer of oil can be quite beautiful.

A mirrored image can produce symmetrical balance in a photograph. Use a mirror, a sheet of rigid black plastic, or reflective Mylar sheeting pulled absolutely flat. Hide one reflector edge by butting it against part of the subject—the wall in this case—and frame within the other edges; expose normally. Photo: M. Craig.

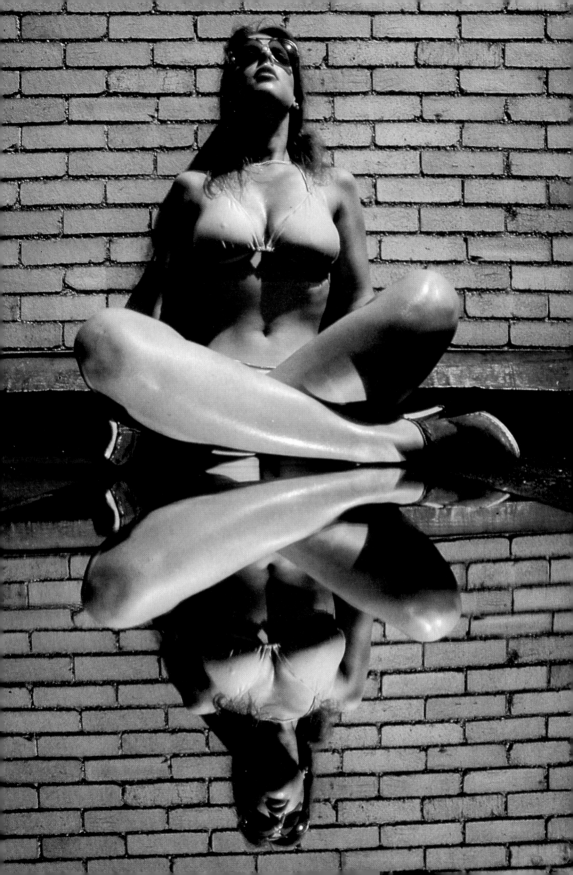

Technique Tip: Photographing Reflections

The important thing to remember when photographing a re-flected image is that you must focus *on the image* and *not* on the surface of the mirror. The image appears to lie as far behind the plane of the mirror as the subject is in front of it. So, if you are photographing yourself as you stand 1 meter (3 ft) in front of the mirror, your point of focus will be 2 meters (6 ft) away. This becomes obvious when you look through the viewfinder of your single-lens reflex camera.

When you want to include the frame of the mirror as well as the image, be sure you have enough depth of field to allow you to keep both sharp. This is also something to be aware of when you photograph another person looking at his mirrored reflection. Be sure to focus on the reflection if you want that to be sharp. By varying the depth of field you can deliberately place the person in or out of focus.

An effective trick is to stick sequins, crumpled aluminum foil, or crumpled colored cellophane on the mirror so it will frame the subject's reflection. Focus on the reflection, using a shallow depth of field, and the image will be surrounded by fascinating highlights.

Once you start searching for shiny, reflective surfaces, you will find them everywhere. Instead of photographing a scene as you normally would, photograph its reflection. Aiming the cam-era at the mirrored facade of an office building can produce a splendid effect, especially when the glass is tinted. If you find mirrored walls that are veined in a marbled pattern, experiment with focusing on the reflection, on the veins, or on both.

Surveillance–type convex mirrors in department stores and street intersections give you a wide–angle view without a wide-angle lens. You will find smaller versions of these on the exte-rior mirrors of trucks. Christmas tree balls will give you a fisheye view of the world—and yourself.

Automobile mirrors provide the opportunity to combine a forward and backward view of the scene. Sit inside the car and compose the picture so both views are included and are sharply in focus. Park the car or let someone else do the driving!

Metal and Glass. Darkly colored clean cars provide very reflective surfaces. The roof, for example, can reflect the sky and part of the skyline, for a cityscape that might otherwise be uninteresting. When the light is right, the reflections on the outside of a curved windshield make fascinating elongated pictures. Take notice of the reflections on store windows and the windows of your house. Check the view from inside and outside the building to see which will let you superimpose an exterior and interior view with one click of the shutter.

Once you look, you will see shiny surfaces everywhere. Most of these will be curved and will distort the image in an interesting way. Colored metals add to the creative effect. For most of these items you will have to work with a close-up lens.

A mirrored image is optically as far behind the mirror as the subject is in front of it. To get both sharp you often will need great depth of field. Otherwise, as here, you must choose to focus on one or the other. Photo: R. von Kaenel.

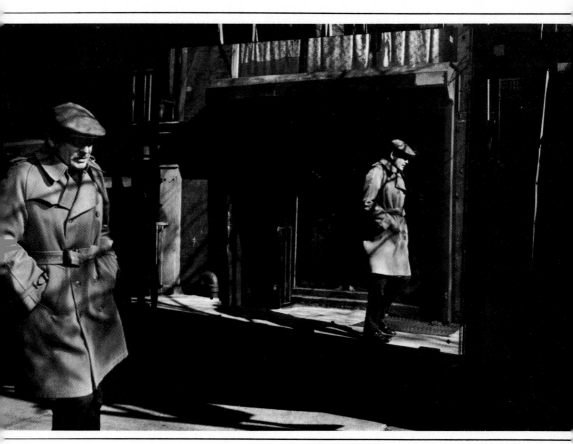

Planned Reflections

MATERIALS AND EQUIPMENT: Hand mirrors, front–surfaced mirrors, clear nail polish, adhesive tape, geometrically-cut mirrors, black Plexiglas, metallized Mylar, aluminum foil, colored paper and cloth, cardboard, tripod, close–up lens.

Rather than photographing reflections wherever you happen to find them, create your own. You might want to take small hand mirrors and cause reflected images to occur in unusual places in the scene. It helps if you have an assistant to angle the mirror so it reflects the subject. You might even try several mirrors scattered around, indoors or out, or work with Christmas tree balls or convex automobile mirrors.

You can use a small hand mirror in a different way. Take a rectangular mirror with no border around the edges. Hold one side against the bottom rim of the camera lens, mirror–side up, and you will see the scene and its reflected image. By manipulating the angle and the placement of the mirror, you can produce different amounts of reflection. To distort the image so it resembles water, coat the mirror with clear nail polish or glue. For a multi–image effect, shatter the mirror and glue it onto a piece of cardboard. Do these shots using a tripod and a shutter speed of at least 1/125 sec. to counteract any shakiness as you hold the mirror.

Broken Reflections. The way to shatter a mirror (so you will have no bad luck) is to cover the back with adhesive tape, wrap the mirror in a towel, and give it one or two firm taps with a hammer. The tape will hold the pieces together so you can handle it easily. You can use a shattered mirror to break up any image into fragments and repetitions. With your subject in front of the mirror, move the camera ever so slightly and watch the changes that occur. The flexible backing will let you bend or twist the mirror for other effects. Try variations like throwing the broken edges out of focus or keeping them as sharp as the image. Check the depth of field with the depth-of-field preview button.

Another way to break up your image is to purchase mirrors that are cut into small geometric shapes and glued to a flexible backing so you can drape and fold them into various positions. An interesting trick is to roll these into a tube with the mirrors facing inside, and place the tube in front of the lens when you make the photograph. Or take a series of rectangular mirrors and place them next to each other, almost, but not quite, at the same angle. By turning them slightly, you will see multiple images of the subject.

Fascinating multiple–image effects are possible when you work with three rectangular mirrors of the same size. These should be good quality, preferably front–surfaced mirrors. Front-surfaced mirrors have the reflective coating on the front of the glass rather than behind

it. The advantage is that there is no secondary or "ghost" image, but they scratch easily and are more expensive than the other kind. (These are best for close-up work.) Stand two of the mirrors on a table so they form a "V" with the closed end away from you and the mirrored surfaces facing each other. Place your subject between the two mirrors, and experiment with varying its distance to the apex. With your camera at the open end, you will be able to photograph a multiple-image pattern of the subject.

More exciting is an infinity mirror arrangement. Instead of using two mirrors in a V–shape, use three. Put one in back and two as moveable side panels, just as they are in a fitting room. Or lay one mirror down on the table with the other two on opposite sides, angled like a tent. Either way, you will be able to vary the number of images so you will see an image of an image of an image. And, of course, you can always take your camera to the clothing store and take multiple–image pictures of yourself.

A similar arrangement of mirrors will give you a kaleidoscope type of picture. Fasten three mirrors together so they form a triangle. The short length of the mirrors should be slightly less than the diameter of the camera lens. Hold it in front of the lens and take your pictures. With all of these multiple-mirror arrangements, a tripod is indispensable. Use as small an aperture as possible in order to have the greatest depth of field.

To avoid reflected images of equipment—and yourself—position the camera a bit above the mirror set-up and mask the tripod with black cloth or cardboard. Add masking at side angles if necessary.

Plexiglas and Mylar. Reflectors do not have to be mirrors. Black Plexiglas is even more dramatic. Flexible polished metal and metallized plastics can be bent and stretched to distort the reflected images. Silver Mylar, Mylar embossed with diffraction grating patterns, and aluminum foil are other exciting things to place in front of your camera. Although Mylar is smooth and shiny, it will not lie absolutely flat, and it can produce interesting distortions. Take advantage of these distortions by taping a large sheet of Mylar to a piece of cardboard, and then twisting and bending it to produce the distortions of a fun–house mirror.

Roll a sheet of Mylar into a tube and place it before the lens. The tube does not have to be perfectly symmetrical, and you may like what happens when you squeeze it into teardrop or lopsided shapes. If you want to make abstract patterns of color, there is nothing better than reflecting colored cloth or paper into a slightly rumpled piece of aluminum foil or Mylar.

Keep on exploring and experimenting. You will find endless things that can be used as fascinating reflecting devices.

Curved reflective surfaces produce distortion because the size of the image varies with the changing distance between object and mirror. The effect looks flowing because the surface change is continuous.

Reflections on bulging or multiply-curved surfaces are grossly stretched and distorted. Its easy to deform mirrored Mylar sheeting for these effects. Photo: H. Petermann/Photogenesis.

Distorting and Multiplying Devices

MATERIALS AND EQUIPMENT: Patterned plastic, patterned glass, multiple Fresnel lenses, glass brick, close–up lens, 10cm (4-in.) square sheet of acrylic plastic, anything that is transparent.

Ordinarily, anything you put in front of the lens should be perfectly clear and as distortion–free as your lens. But, sometimes a diffused or distorted look is just the thing to add surprise, mystery, or humor to a picture.

Plastic. Go to your local plastics store and buy an assortment of small sheets of textured plastic. Put the plastic on top of an object you want to photograph and notice the distortion. Some designs in the plastic will change the subject only slightly, giving it a painterly effect, others may make it seem like it is composed of mosaic tiles, while others will completely convert it into areas of abstract color. Notice how much more distortion there is as you raise the plastic from the subject. This principle holds for most distorting devices—the farther

Photographing through patterned glass will produce patterned simplification—and abstraction—of subject shapes and colors. Photo: T. Tracy.

Patterned glass was used for this haunting photograph of a woman. Check refrigerator shelves, cabinet doors, and shower stalls for patterned glass or plastic panels around the house. Many common glass objects will produce interesting distortions when placed in front of the subject and the lens. Photo: J. Peppler.

the device is from the subject the more distortion there is. Try propping the textured material upright, supporting it between books or slotted pieces of wood.

If you want a distortion device that is distinctive, make your own. At your plastics craft store, buy pieces of 0.125cm (⅛-in.) or 0.625cm (¼-in.) clear acrylic plastic. The pieces should be about 10 × 15cm (4″×6″), but the size is not critical. Hold the corner of one of the pieces with a pair of tongs and heat it over the kitchen stove until the plastic becomes soft and floppy. With your hands protected by oven mitts or potholders, push and bend the plastic into ripply folds. When it looks interesting, reharden the plastic by plunging it into a bowl of warm water. To use it, hold it in front of the lens with your hand or tape it to the outside of the lens.

Glass. Glass also comes in a variety of patterns which you can use in the same way. You may already have sheets of distorting glass in your house. Refrigerator shelving often has glass inserts that you can borrow for your photographs. If you need a really large piece, you may be fortunate enough to have a glassed–in shower with patterned glass

as the door. Bathrooms are used as darkrooms, so why not photographic studios!

Look around in buildings for dividers and other architectural devices that are transparent enough to photograph through, while contributing a significant amount of distortion. Around your house, you can certainly find transparent items, either colored or clear, that will will be fun to photograph through. Anything that is not optical glass will automatically distort whatever you shoot through it. For instance, try photographing a distant scene, including the sun, through a drinking glass held right over the lens. Glass bottles, cut glass bowls, a piece of plastic bubble wrap are all interesting possibilities. Do not overlook clear plastic or glass with a small colored design—when close to the lens, the design will blur into a mass of color.

Glass bricks make fine distorting devices. Move your camera and subject until you see the distortion that pleases you. Use a tripod so you do not lose that critical position.

Fresnel Lenses. Fresnel (pronounced "freh–nel") lenses are circles of glass engraved with many concentric circles which give you a

Set-up for an abstraction: hanks of colored yarn, a glass brick, and a textured vase.

The objects shown on the facing page were photographed close up to create this bizarre abstraction. The technique is simple to accomplish and can be done with many objects that are readily available. Photos: A. Balsys

180–degree angle of view—like a fisheye lens. You can get inexpensive copies of these lenses made of plastic. The large ones, about 27.5cm (11 in.) in diameter, can be used as pseudo-fisheye lenses. Multiple Fresnel lenses are small lenses grouped together on a sheet of plastic. When you look through them, you will see many small images of the subject. Those most commonly available are made of soft plastic and have 19 lenses. They are sold in hardware stores and attach to a window by pressure alone. Another type has nine lenses on a rigid sheet of plastic. When you focus the camera you will find that you will be focusing on the surface of the lens rather than on the more distant subject. In order to avoid showing the edge of the plastic, you need to be able to focus to a distance of 35cm (14 in.).

7

Tricks with Tabletop Photography

Shadowless and Reflectionless Lighting

MATERIALS AND EQUIPMENT: Styrofoam cup, black velvet, photolamps, white tracing paper, white fabric, black, flocked Contac paper, light box, cardboard, Foamcore board.

In "still-life," or "tabletop" photography, it is always a challenge to find the best way to light your subject. It is most difficult when you must eliminate shadows or reflections.

Tenting. In Chapter 7, the object was to photograph reflections themselves. But you might not want to see your face, camera, and surrounding walls reflected in a carefully arranged set–up of silver bowls and candelabra. To eliminate reflections, you must erect a barrier between the subject and the rest of the room—yet still have a way to illuminate the objects, and a place to poke the camera lens.

"Tenting" is the answer. Construct a cone of translucent material, place the light outside of it, cut a whole for your camera lens to peak through, and you are ready to shoot. A styrofoam cup serves as an efficient tent for jewelry, coins, or other small objects. Cut the bottom out of the cup and force it over your lens. Then place the open side over the object on a table. Although it may seem sturdy enough, it is best to secure the camera on a tripod. The object will reflect the overall whiteness of the area surrounding it, so you may want to place it on a dark background to add some contrast. Black velvet is the best material to use. Paper or other fabrics reflect glare and will not photograph as a rich color. For objects of this size, one photolamp should provide sufficient illumination.

This assemblage is simply a directly photographed arrangement of feathers, a fishing lure, and a spool of thread on top of an old engraving. Lighting that produced almost no shadows was required to blend everything into a unified image. Photo: J. Sarapochiello.

You will have to meter carefully. The most reliable way is to put a neutral gray card inside the completed set-up before you place the object there, basing your exposure on the reading of the card.

Larger objects require larger tents. One of the best materials to use is heavy tracing paper, available in art and drafting stores. Form it into a cone shape and fasten it together with tape. Before you set the tent in place, decide where the camera will go. If you intend to shoot from above, then the cone can go around the lens, like the styrofoam cup. Most likely you will want the camera in a lower position. To accommodate it, cut a round hole in the side of the tent, and use this as a window for your camera to peek through. Generally, one lamp outside the tent will be sufficient. The tent surface will diffuse the light, yet one side will have more illumination than the other, providing a sense of modeling.

Another useful set–up is a square tent. This involves nothing more complicated than turning a card table upside down, and draping the top and sides with white fabric. Nylon knit fabric is inexpensive, resists wrinkling, and is nice to have around for backgrounds. You may want to rest the card table on top of another table to put it at a more convenient working height. Lay a board or something firm over the framework of the card table to provide a flat base for your subject.

Observe the arrangement carefully, making sure there is contrast between the subject and the background. A good way of providing contrast is to place a black panel behind the subject. Apply black,

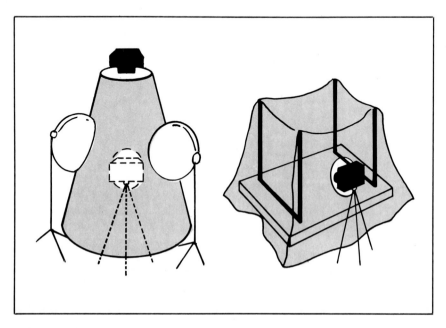

(Left) A paper cone tent. Shoot through the top or a hole cut anywhere in the side. Use one light outside for directional lighting, two lights for even coverage. (Right) White cloth draped over upturned table legs makes a large tent. Place lights outside and shoot through a slit as required. Tracing paper can be taped to legs in place of cloth.

For shadowless lighting, place object on a sheet of plate glass or a window supported by chairs or stacks of books. Light a curved white paper background from below at least one f-stop brighter than the object. Use diffused or bounce light from above on the object. Frame shot to not include edges of glass.

flocked Contac paper to cardboard or Foamcore board, and you will have a maneuverable device to work with.

For very large objects, turn an entire room into a tent by hanging white bed sheets all around, placing as many lights as necessary behind them.

Light Boxes. When you want an opaque object to seemingly float over a background, throwing no shadows, diffusing the light is the answer. Any of the tenting arrangements will diffuse the light enough to eliminate the shadows. Another way is to stand your objects on a light table. You can make a simple one by supporting a sheet of glass —or a storm window—between two chairs. Arrange a large sheet of white paper so it falls in a smooth curve from above and behind the glass and curves over it. Place a lamp underneath the glass, and it will nullify the shadows caused by a weaker lamp that you use to illuminate the subject.

Bouncing the light is probably the easiest way of all to remove shadows. Instead of directing the light toward the subject, aim it at a white ceiling or a large sheet of Foamcore board.

Still-Life Photography

MATERIALS AND EQUIPMENT: Close–up lens, tripod, junk, bottles of water, soda water, food colors, cardboard, Foamcore board, aluminum foil, colored acetate, photolamps, fabric, colored foil, textured glass or plastic.

A still life can be thought of as any carefully composed and well-lighted arrangement of inanimate objects. Special effect still lifes are different only in that they use more unconventional subjects, backgrounds, or ways of shooting. All sorts of objects make for interesting photographs. Traditional ones, like pottery, decorative accessories, and well–shaped produce, can be lovely, or try more unusual things such as misshapen produce, pieces of broken equipment, bits of glass, feathers, old photographs, marbles, skeletonized fish.

Gather your treasures and make a pleasing arrangement by following your own intuition. Try things that go together logically—like a cup and a decorative platter—or unlikely combinations such as pieces of coal and a diamond bracelet.

Backgrounds. Think about the background while you are putting things together. A plain wall is fine, especially if the work table is not butted against it. Large sheets of white, gray, and colored cardboard

Backgrounds for tabletop photography generally are created with large sheets of paper or plastic. The single surface of the sheet eliminates the line created where the table meets the wall and thus provides a less distracting background. The placement of lights will change depending on the background material being used.

Select a simple background for still-life arrangements and close-ups of interesting objects. Use material that complements the subject in both color and texture. Photo: J. Child.

are especially useful. Another way to make a background is to push your work table next to a wall, tack a large sheet of paper to the wall, then let the paper fall gently over the table in a smooth curve. This method will give you a seamless background, with no horizontal lines visible behind your subject. For more unusual effects, paint this background with randomly applied colors. Or try something reflective— slightly crumpled aluminum foil, Mylar, or a plain, dark background sprinkled with silver glitter. If you light it so it catches bright highlights, you can use a star filter or highlight modifier on your lens.

Backgrounds do not have to be opaque. Prop a sheet of glass or plastic behind the subject so light can come through it. Tape colored acetate to the glass, or throw the background out of focus, and use abstract shapes of many colors to achieve a stained-glass effect. Stand the arrangement in front of a white wall or sheet of cardboard. Shine a light onto the white wall and it will illuminate the background evenly. This background works well with transparent objects.

If you use a light box, you can light objects from below, as well as behind. An advantage of this vertical arrangement is that you can create a two–level set–up with an additional sheet of glass propped on some books. You have your choice of keeping both levels in focus or throwing the background out of focus. Also experiment with leaving different amounts of space between the two levels.

To add color variety to a photograph of glasses or bottles, fill them with water dyed with food coloring. Photo: T. Tracy.

Lighting. To light a still life you can use window light, but photolamps give you more control. Place one light somewhat off to the side, and try using a reflector of white cardboard or Foamcore board to lighten the shadows. Or use two lights, one for the main light and a weaker one on the other side of the subject. (Use a backlight to provide separation of the object from its background.) Place a reflector in front of the subject.

Adding Color. Still-life photography is wonderful for experimenting with color and unusual light sources. Use colored acetate, your slide projector, or a flashlight. Another way to inject color is to use colored cardboard or aluminum foil as a reflector.

Take a glass bottle, place an object close behind it, and photograph it in some of the following ways:

1. Through the empty bottle.
2. Through the bottle filled with water.
3. Through colored water made by adding food coloring. Take the picture just as you add the coloring and later when the water is evenly colored.
4. With soap bubbles added to either plain or colored water.
5. Use front- or backlighting and look for patterns that fall on a white tabletop as the light shines through the colored water.

Instead of a bottle, use a glass bowl or a thin fishtank. Place cloth,

colored papers, colored foil, and other things behind the bowl to make colorful abstract pictures whose patterns will change with every position of the camera.

Or take a drinking glass or other vessel made of clear, thin glass and put a flower or other object in it. Fill the glass with part water and part soda water. Wait a few minutes and take the picture when the object is covered with tiny bubbles.

In any of these tabletop techniques, try using special effects filters and front lens attachments. Star filters, diffusion devices, diffraction gratings, and other devices make for some spectacular pictures.

Only the background behind the glass below was lighted; black cards on either side added form-enhancing reflections. The tall glass was placed in front of a black background and illuminated by light reflected from a white board on each side. Photos: B. Docktor.

Models and Other Tabletop Effects

MATERIALS AND EQUIPMENT: Tripod, photolamp, reflectors, close–up lens, cable release, scaled–down objects, backgrounds.

Model photography has characteristics of photographing both live subjects and still lifes, but it also has its own unique problems. The models being discussed are things that are smaller than their real–life counterparts—either single objects or things arranged into a scene. You can use model trains and cars, doll houses, or whatever you can make, borrow, or buy.

You can work most comfortably if you place the objects on a table rather than on the floor, although this may not always be practical. The larger the scale of the model, the easier it will be to photograph. One of the problems you will encounter is depth of field, especially trouble-some with very small objects and a close–up lens. If you have a scene of a train traveling along the countryside, the equivalent real–life picture would have a depth of field extending to infinity. Not so with the scaled–down replica. To avoid disclosing that this is not the real thing, use as small an aperture as possible. This will mean longer exposure times, which should be no problem as long as you use a tripod and cable release. The distance of the camera to the subject also influ-ences the depth of field, so a wide–angle lens with a close–up attach-ment may be a good idea. You might want to draw or paint a back-ground that you can place close to the subject, where it will be in focus. To preserve the illusion of reality, you will have to force the lines of perspective, exaggerating the way they converge.

A tricky effect is the astounding appearance obtainable by placing an object in a scaled–down environment. You can make a normal piece of fruit look enormous if it is surrounded by miniature kitchen utensils, and you can destroy the relationship of cat and mouse with replicas in different scales.

Backgrounds. Slightly out–of–focus paintings make good back-grounds, as do photographs. Be sure the direction of the light in the background corresponds to the lighting on your set–up. Slides are even better than prints because you can make them whatever size you want. If you project the slide from in front of the screen, as you normally would, part of the image will fall on the subjects. It is better to use rear projection, that is, to place the projector in back of the objects and project the slide on a translucent screen. There are screens especially made for this purpose, but for occasional use, you can improvise with

a sheet of matte acetate or glass covered with tracing paper. If signs or other writing is in the picture, put the slide in backwards so it will read correctly from the camera side.

Generally, you will want to use a low camera angle, simulating the view of an observer looking at the scene. But you can take advantage when using a model to get the "aerial views" you ordinarily would not be able to shoot.

 Technique Tip: Making Your Models Look Real

There are all sorts of little things you can do to enhance the realism of your picture or to make it look extraordinary. If you need a lake, for instance, take a small hand mirror and coat it with clear nail polish or glue. Fog? Blow smoke across the scene just before you shoot. Clouds—fluffy bits of absorbent cotton. (Use the real stuff, not synthetic. Be sure their shadows do not fall against the background.)

Salt, sugar, baking soda, or powdered detergent all make good snow. For frosty windowpanes, spread rubber cement on the glass and sprinkle it with powdered sugar. For stars in a night sky, use a sheet of deep blue or black paper, poke holes in it, place a light behind it, and use a star filter on your lens. To emphasize the reflectivity of a bottle or a piece of glass, put a piece of aluminum foil behind it.

The scene should seem to have one dominant light, and one light may be all you need. You may want to use sheets of white cardboard to reflect light back into the shadows. Crumpled and smoothed–out aluminum foil stapled to a sheet of cardboard make reflectors, as do small mirrors.

8

Tricks with Unusual Films

Infrared Films

MATERIALS AND EQUIPMENT: Kodak High Speed Infrared Film 2481; Kodak Ektachrome Infrared Film; No. 12, No. 25, and assorted other color filters.

There are two types of infrared film: black–and–white and color slide film. Both of them are sensitive to invisible infrared radiation as well as to some visible light. This sensitivity produces unusual tonal renditions in black-and-white and fantastic hues in color. You must handle infrared films differently than ordinary emulsions. First of all, they must be stored under refrigeration—in your home and *on the dealer's shelf.* Allow the film to warm up to room temperature for several hours before exposing it as well as before processing. Return exposed film to the refrigerator if it is not to be processed immediately.

The second handling rule is to open the canister, load the film into the camera, and remove the film from the camera *in complete darkness.*

Black–and–White. Landscape photographs made on infrared film have a luminous glow with dark skies, white clouds, and foliage that is almost white. Haze, which would be present in an ordinary shot, is miraculously penetrated. Portraits of people show no wrinkles or blemishes, and there is a pleasing grainy quality to these images.

To use this amazing film you will need to block some of the visible light with a No. 25 red filter, or else the photograph will look like one made with ordinary film.

Color. You will be amazed when you see the unreal colors that color infrared film will produce. Leaves may turn red, hair may turn green, skies may turn bright yellow, and almost anything can happen to other objects! Although you may not always know what colors you are going to get, you will have fun with it.

Ektachrome Infrared film offers a multitude of otherworldly color effects. It can be used with a wide variety of filters, but for a start use a No. 12 deep yellow filter. Sunlight and electronic flash are infrared-rich light sources. Keep the film cool when storing it and process it as soon as possible after exposure. Photo: H. Weber.

Photomicrography and Vericolor Slide Films

MATERIALS AND EQUIPMENT: Kodak Photomicrography Color Film 2483, Kodak Vericolor Slide Film SO–279, assorted colored filters, photolamps, tripod.

These two films are fascinating to work with because their colors are different from those produced on ordinary slide films. Photomicrography Film is specifically intended to be used in scientific and industrial applications where high definition or high contrast is required. Vericolor Slide Film was designed for making slides from color negatives. Although neither of these films is intended for pictorial photography, there is no reason not to experiment with them.

Photomicrography Color Film 2483. This film will produce positive images to be viewed as slides. It has extremely fine grain and high resolution. Its dramatically high contrast and color saturation are the features that throw it into the special effects category. It is a fairly slow daylight film with an ISO/ASA of 16, but on a sunny day you should be able to handhold the camera. It is supposed to be used in daylight, but sometimes you can get pleasing results indoors.

The film is partial to certain colors, intensifying and brightening them. Reds, in particular, seem to glow and orange becomes vibrant. Blue is rendered in incredibly rich shades. Browns also are enhanced. On the other hand, yellow turns pale and some greens, particularly grass, shift to a yellowish hue. It does horrible things to skin, turning it magenta. In a landscape shot, particularly snow scenes, the overall effect will be pinkish or magenta. If you insist on correcting this, you can use a pale green color compensating filter, such as CC20G to get rid of the excess magenta. Polarizing filters have an adverse effect on the image; do not use them.

The time to use Photomicrography Film is when you want to emphasize blue, red, or orange colors in the picture. Imagine what will happen with shots of sunsets, blue water, or close-ups of autumn leaves. Close-ups of all sorts and elements with strong design patterns are subjects worth photographing. You might also like the high-contrast, posterlike effect you can achieve when copying slides. It is a good film choice if you want to perk up the contrast of a scene being shot on an overcast day or in open shade. It also allows you to record a zooming or blurred subject without washing out the colors. Indoors, you will get natural colors under fluorescent lights without using a correction filter. You can achieve pleasing results under tungsten light, or even mixed fluorescent and tungsten lights.

The film stands up well with long exposures. It maintains the color saturation, and greens and yellows are improved. You can enlarge pictures made on this film without fear of seeing a lot of grain.

You must meter very carefully and bracket plus and minus ½ stop. The film has a very small latitude for exposure error. If you overexpose, the highlight detail will be lost and the colors will be weakened. Underexpose, and the colors will become muddy. The best light to shoot in is early morning and late afternoon, avoiding the stark shadows of noontime. Store the film under refrigeration or in the freezer, as it deteriorates quickly with age.

Vericolor Slide Film. Although this is called a slide film, it will give you a negative image. That is, the colors that you photograph will appear in their negative hues on the film. If you always thought it might be interesting to have color negative images, this film makes it possible. Other negative films have an overall orange cast, which makes them unsuitable for projection.

The film is balanced for tungsten light, so you will need to use photolamps. It is quite slow—about ISO/ASA 6—so you will need a tripod. Your exposures should be kept between ½ and 8 seconds. Take a meter reading from a gray card, and bracket your exposures by ½ stop. Because it is a negative-acting film, more exposure will make it darker and less will make it lighter.

The results? The accompanying table summarizes the way the subject colors will appear on film, but the hues will vary with different amounts of exposure.

COLOR EQUIVALENTS ON VERICOLOR SLIDE FILM

Subject Color	Color on Film
blue	yellow or orange
yellow	blue or purple
green	magenta
magenta	green
white	reddish black or black
red	cyan
black	white
cyan	orange

Protect the film against heat by storing it in a refrigerator or freezer, allowing it to warm to room temperature before opening the canister. You can process the film yourself in C-41 chemicals or send it out. If a processing laboratory does the work for you, tell them to "process only"—otherwise you may get back prints. You will have to cut and mount the film in slide mounts yourself, as the processor does not provide this service.

High-Contrast Films

MATERIALS AND EQUIPMENT: Kodalith Ortho Film No. 3, Kodak Technical Pan Film 2415, litho A and B developer, D-19 developer, white paper, black lettering materials, non-reproducing blue-lined illustration board, photolamps, tripod, watercolor dyes, colored acetate, slide mounts.

There are films that will produce pictures of such extremely high contrast that only jet black and clear white areas remain. The pictures are startlingly different from continuous-tone black-and-white photographs, which have a full range of intermediate gray tones. With these high-contrast films, shadow areas of the subject become black and so do all other tones that normally would be rendered as medium or dark gray. Everything that you would expect to be in lighter gray tones will be white. With the right subject, it makes for a dramatic picture.

Kodalith film is one of these special films. The "lith" in its name indicates that it is a lithographic film made for the printing industry. Several manufacturers make similar litho films in sheet form, but only Kodak makes it in 35mm size. If your photo store does not have it, you will find it in stores that sell graphic arts supplies.

Until recently, Kodalith was the best film to use when you wanted to make high-contrast images in the camera, but now there is an alternative: Kodak Technical Pan Film 2415. You can buy it in 36–exposure magazines or in longer rolls for bulk–loading. The major advantage of Technical Pan Film is that it is faster. Litho is rated at about ISO/ASA 8, whereas Technical Pan is ISO/ASA 100. It is somewhat slower in daylight, about ISO/ASA 36. Kodalith is blind to red—anything red in the subject you are photographing will render itself as black—but

Technique Tip: Shooting with High-Contrast Film

Focus sharply. Slightly blurred edges make the picture lose its effectiveness. Because the picture will lack the appearance of depth that a continuous-tone picture can have, it is best to plan your composition so there are no out–of–focus foreground and background objects.

When you take the picture, bracket your exposures in ½-stop intervals. This will insure that you arrive at the best exposure. Interestingly, the one you like best may actually be one that is far from what the meter reading would indicate. If you cannot set the ISO/ASA indicator as low as 8, put it on 16 and give the film one stop more exposure than indicated.

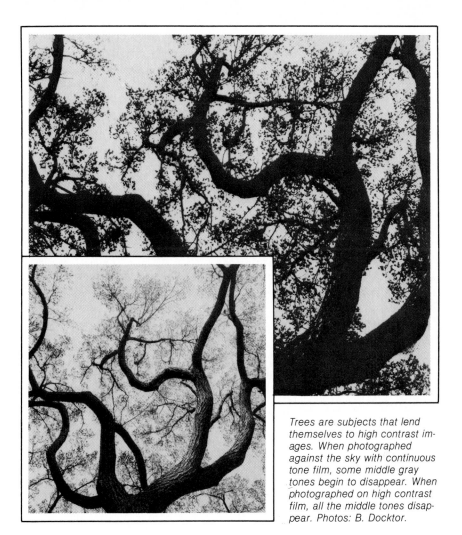

Trees are subjects that lend themselves to high contrast images. When photographed against the sky with continuous tone film, some middle gray tones begin to disappear. When photographed on high contrast film, all the middle tones disappear. Photos: B. Docktor.

Technical Pan is sensitive to all colors. Kodalith's lack of sensitivity to red has the advantage of letting you process it under a red safelight. Technical Pan must be kept in the dark.

Best Subjects. Many subjects lend themselves to the type of pictures these films can produce. Subjects that are already high in contrast, due to the lighting or their colors, are good because they give you an indication of how the picture is going to look. Textured surfaces—animal fur, a tweed jacket, weathered wood—are enhanced. Objects with identifiable outlines, such as would be suitable for silhouettes, are ideal since these films often reduce the picture to a silhouette. Stay with simple forms, and position the camera so that one object is not in front of the other, causing both shapes to merge and become indistinguishable. Trees, bridges, electrical towers, and sailboats are a few of the things that you can photograph successfully.

Index